LEARNING
TO SEE
CREATIVELY

THIRD EDITION

LEARNING TO SEE CREATIVELY

Design, Color, and Composition
in Photography

BRYAN PETERSON

AMPHOTO BOOKS

Berkeley

> "Some might think that creativity is in short supply, but in fact most shooters suffer from an oversupply of complacency. Demand more of yourself!"
>
> —BRYAN PETERSON

Published in the United States by Amphoto Books,
an imprint of the Crown Publishing Group, a division
of Penguin Random House LLC, New York.
www.crownpublishing.com
www.amphotobooks.com

AMPHOTO BOOKS and the Amphoto Books logo are
registered trademarks of Penguin Random House, LLC.

Previous editions of this work were published by
Amphoto Books, New York, in 1988 and 2003.

Library of Congress Cataloging-in-Publication Data

Peterson, Bryan, 1952- author.
Learning to see creatively : design, color & composition
in photography / Bryan Peterson.— 3rd edition. pages cm
Includes bibliographical references and index.
1. Composition (Photography) 2. Photography, Artistic.
3. Picture perception. I. Title.
 TR179.P47 2015
 770'.1—dc23
 2014049147

Trade Paperback ISBN: 978-1-60774-827-4
eBook ISBN: 978-1-60774-828-1

Printed in China

Design by Kara Plikaitis

10 9 8 7 6 5 4 3 2 1

Third Edition

ACKNOWLEDGMENTS

Thank you so much to my very familiar editor,
Alisa Palazzo, for joining me once again and bringing
your always welcome editing skills to my many books.
To Kelly Snowden, my new editor, and to Jenny Wapner,
executive editor—here's our first of many new books,
I am sure, to be published by Ten Speed Press.
Are we having fun or what!?

Thanks also to the Weather Girl who illuminates
this Storm Chaser's life with an always warm and sunny
outlook. Thanks also to my two daughters, Chloe
and Sophie, and to my son, Justin, for putting up with
my relentless pursuit of photographic excellence.
Finally I want to say thank you to my many photography
students and YouTube followers for your generous words
and comments. Until next time, you keep shooting!

CONTENTS

INTRODUCTION

All of us who are blessed with sight can see, but why is it that someone right next to us can see something of interest, yet we somehow miss it? If you've ever participated in a photography workshop in the field or gone out shooting with a friend, you know what I mean: Standing at the head of a trail you are bewildered, lost, and confused, while someone else is setting up a camera and tripod three feet away, zeroing in on a graphic composition of autumn leaves. You watch in amazement and ask the most often-heard question at workshops and field trip outings: "Why didn't I see that!?"

The answer may be a combination of things. Perhaps you were preoccupied with thoughts about your job or hadn't dressed appropriately and were shivering like crazy. Not being able to see is probably the greatest hurdle every photographer has to overcome, but it is a skill you can hone with work and dedication. Once you begin to see—really see—you are faced with the next hurdle: composing all that great stuff in a balanced and harmonious fashion.

The aim of this book is not only to teach you how to recognize a picture-taking opportunity but also to challenge that conservative way of seeing that often leads to dull, ordinary photographs. Throughout this book, many of the examples are pairs of images that show you before and after, as well as good and better. These pictures are not intended to be the right way but are simply my interpretation of a particular scene at that particular moment in time.

Twelve years have passed since I revised the original edition of *Learning to See Creatively*, which was first published in 1988. Despite the many advances made in the photo industry, including the cameras that come with every smartphone, the challenge of creating compelling imagery still remains: to advance your personal vision, you must really practice and exploit not only the vision of your lenses but also a willingness to consider a multitude of differing points of view under various light and weather conditions.

This all-new edition of *Learning to See Creatively* explores the subject of personal vision in great depth, with accompanying exercises throughout that promise to unleash the visionary in you—regardless of technology. Even if I

did employ the latest and greatest camera, lens, or photo-imaging software program, it would have very little impact on the one vital ingredient that separates a ho-hum image from an OMG ("Oh, my God!"): personal creativity.

Creativity is perhaps best described as a combination of inventiveness, imagination, inspiration, and perception. The photography industry has yet to introduce a camera that searches out unique and interesting subject matter. There still isn't a camera that will alert you to other compelling compositions that lie in wait next to the one you're currently shooting. There still isn't a camera that instinctively recognizes the "decisive moment." And, there still isn't a camera that will systematically arrange your composition in a balanced and harmonious fashion before you trip the shutter release. These are challenges that continue to be part of the wonderful world of image-making, challenges for which the sole responsibility of success or failure rests squarely on your shoulders.

When I wrote the previous edition of *Learning to See Creatively*, I had one goal in mind: to dispel the myth that the art of image-making was for the chosen few. Based on the overwhelming and positive responses I've heard at my many workshops and online courses, as well as those contained in the many letters and emails I've received, I feel I reached that goal. This all-new, completely rewritten and reillustrated edition will continue to dispel that myth. In addition, I've added a section on my use of Photoshop and how I believe it is another exceptional tool for image-making.

Learning to see creatively is also very dependent on what your camera and lens can and cannot see. Captains of ships need to become very familiar with their maps as they navigate the world, making certain to keep their ships pointed in the right direction. In much the same way, your lenses are maps that can lead you to new and enchanting lands. With constant practice, which comes by placing the camera and lens to your eye, you'll begin to visually memorize the unique vision of each and every lens—both the pluses and the minuses. The more you do this, the less likely you'll be to ever see the world in the same way again. You'll learn just how vast an area a wide-angle lens can cover, or how a telephoto lens can select a single subject out of an otherwise busy and hectic scene. It won't be too much longer until you'll find yourself knowing, without hesitation, what lens to use as you see one picture-taking opportunity after another.

Then you can begin to take this newfound vision to even greater heights, challenging yourself to view the forest from a toad's point of view, or the city streets from a sidewalk point of view, or your backyard from a robin's-nest point of view. (Ladders are not just for housepainting.) Lie on your back at the base of a large fir tree, and show me the point of view of the squirrel that raced up it only moments ago. Set your camera on the shoulder of the road, and fire away just as the big semitruck comes into view. A composition like this will, for example, make it dramatically obvious why it is so important that the city council build a small underpass for the ducks that cross that busy road every spring.

Most people aren't aware of this, but I have struggled with my actual role in the creative process of image-making. For years, I've been limited to making decisions about what parts of a given scene to include and what parts not to include—essentially a creative process that begins and ends with my making a deliberate choice in the overall composition. Yes, I'm fully aware that the right composition will often determine if a photograph "works" or not, but I have always wished for a greater sense of involvement.

Let's say that I, like thousands of others, set up my camera and 16–35mm lens on my tripod and proceed to frame up the famous Horseshoe Bend near Page, Arizona. I time it perfectly, and there are few other tourists and a wonderful sky of clouds with the sun peaking through at sunset! Bang, bang, I get the shot and head back to the car. Again, what did I just do that could be considered anything remotely creative, other than make a composition that places the emphasis on the landscape below with a smidgen of sky and sunset near the top quarter or fifth of the frame? My technical skills helped me with determining exposure. Nikon made the lens that, when at 16mm, just happens to be the perfect angle of view, Bogen made the tripod (so sharpness was assured), and of course Mother Nature made the landscape as well as the clouds and sun. So, other than making a conscious effort to record a composition that would render the scene before me with both balance and tension, what other creative act did I perform? And lest we not forget that the scene I just photographed has been photographed no less than

ten thousand times before by others who are equally "talented," if not much more so than I. So again, what did I just do that will allow me to lay claim to the idea that I am "creative"?

I want to stress that this is by no means an attempt to disparage other photographers, especially nature shooters! Again, I know how much personal responsibility goes into choosing the lens and point of view and, ultimately, the final arrangement that will either make or break the shot—i.e., composition. Heck, I've written an entire guide devoted to understanding composition! But as the years have gone by, I have been pushing myself further and further away from the "obvious" photographic opportunities and more toward the "unseen," as well as toward creating images from "scratch" (i.e., using props and/or models, and creating compositions that are in fact inspired in part by observing the world around me or simply writing down those ideas that seem to pop in my head over the course of a day). In many but not all cases, these photographs are what some would call "staged" or "propped."

Yes, staged or propped, and I cannot stress those words enough! And just so we are all clear here about what I'm saying, staging or propping a photograph simply means that I might be adding something to or subtracting something from the photo, or that I'm about to re-create a street scene that I wasn't quick enough to react to on the first go around so I ask the person to "do it again!"

Many photographers are purists. How do I know? I've met them at the many slide shows and lectures I've given around the world, and many have taken the time to write me and share their staunch belief that "staging" or "propping" a photograph is tantamount to "kidnapping." The argument is always the same: don't mess with the "natural" scene before you; shoot it just as it is! Why? That is an important

question, and I really want you to think long and hard about why people are so dead set against removing or adding something to a scene. Well, so much for giving you enough time to think long and hard about this! The argument is weak and here's why: by the mere act of choosing a lens and cropping an image, you, too, are removing and adding something to the overall composition. As you move in closer to that lone flower, you are removing the sidewalk behind it, and as you switch from the wide-angle lens to the telephoto to better isolate the flower, you have also removed the distant car. Then you changed your point of view again and composed this lone yellow flower against a sea of red in the background by

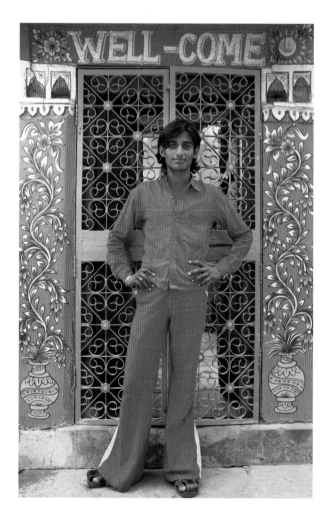

adding the nearby, albeit out-of-focus, red barn! It's clear that by the mere act of lens choice and point of view, you are subtracting objects from the scene or adding something to the scene.

So, what is so wrong with the following? I go to the grocery store, buy some yellow flowers, bring them home, put them in a vase, take them outside onto my deck, grab one of my bright red T-shirts, and hang it in the background so that, when all is said and done, I too have a lone yellow flower against a background of red. Why is what I just did any different from what you just did in camera with your lens and point of view?

Staged or not, most of my creations do look believable, and those that don't make it obvious that they are done with humor in mind. To be clear, believable simply means that the image is looked upon without suspicion. Yet clearly, when I have come up short in my attempts at staging, it's obvious to most everyone—i.e., "That was done in Photoshop by combining several images!" or "The moon in this photograph isn't the same scale as its surroundings" or "How do you explain the backlight in this scene while the subjects are clearly frontlit?" and so on. The lesson here is that if you are going to stage or bring props to a photograph, make it believable or make your creation so outlandish, so truly unbelievable that no one will deny that it is clearly staged (for example, a goldfish in a bowl that appears to be reading the *New York Times*).

I am a huge fan of compelling images that stop me cold in my tracks, staged or not! I am reminded of a recent story about French photographer Robert Doisneau. You may be familiar with his image of the young couple kissing as they walked hurriedly past a French café. Doisneau had been hired by *LIFE* magazine to get some shots of "loving couples" in Paris. The story went that Doisneau was just sitting

at the café when he spotted the couple walking toward him, quickly grabbed his camera, and fired off several snaps as they rushed on by. No one had any reason to doubt Doisneau's story, in large part because the photograph was truly believable and Doisneau was well on his way to making a name for himself as a successful Paris street photographer. It wasn't until much later, in the late '90s—when the young woman in the photograph, Françoise Bornet, sued Doisneau, asking for compensation for her morning of "modeling" for what had now become an internationally famous and best-selling poster—that the real story came to light. As it turns out, Doisneau did see this real couple kissing at an unknown location and asked them to share a kiss in three different locations, including the now famous *The Kiss* spot, which was a café very near the Hôtel de Ville. Doisneau clearly had great vision. He had the vision to see that kiss and its very meaningful potential, and in my opinion, *Le Baiser de l'Hôtel de Ville* remains as one of the best "staged" decisive moments in

photographic history. For some, I realize, the fact that it is staged diminishes, if not ruins, the great capture that it is, and to those of you I ask, "How dare you react with laughter or crying or screaming or anxiety when watching a Hollywood movie! Don't you realize the entire movie has been 'staged'?"

As I mentioned, if people are involved in the creation of one of my images, you can be assured that I have sometimes directed them to stand, walk, sit, jump, or climb in a certain way. And in some cases, I position the subject matter that's part of these staged compositions within the frame deliberately and at a particular spot. In other cases, I have deliberately removed objects (perhaps a chair, a garbage bag, or a piece of paper) prior to recording the exposure. I do this (whether by my composition or my physically moving items out of view) simply because those elements would prove to be distracting if allowed to remain within the composition. I refer to this removal of objects as "cloning before the shoot." If you aren't familiar with cloning in Photoshop (see page 138), it's a function that allows you to remove some objects quite simply (for example, cigarette butts, gum wrappers, and the like). On a related note, I've witnessed countless students shoot cluttered compositions, and when I suggest that they remove the distractions if possible, their reply is often, "I was going to just crop that out in Photoshop" or "I will just clone it out when I do my postprocessing" or "I'll just remove it with the Content Aware tool."

Upon hearing those types of replies, I respond, sometimes in a thunderous tone, "We are here right now, and you are not going to leave without first 'cloning' with your feet. Now walk into that scene and pick up those three cigarette butts and that lone piece of trash next to the table, and simply take that one chair and move it outside of the frame. Now take your shot, and voilà, there is no need to do any cloning or cropping when you return home."

To be clear, the tools of Photoshop have their place in the world of learning to see creatively; even I embrace the wonderful world of Photoshop. But when you allow Photoshop to take over the simplest of tasks, you are missing out on the organic experience of taking responsibility for much of that raw file you are about to record.

And to be even clearer, I'm not suggesting one should use Photoshop only sparingly! Can you imagine limiting a chef to only three items or a painter to only three colors or a writer to only three story lines? I say shoot without limits, and that includes the generous use of several invaluable tools in Photoshop. With my Photoshop tips and namely the use of Adjustment Layers and Layer Masks, you'll find that there's really nothing your vision can't accomplish! If you can "see" it, you can create it.

If you are going to truly pursue the creative process at all levels, then it is my belief that you should consider all the potential tools at your disposal, because, ultimately, it is your vision that defines you. Perhaps your vision begins and ends with a single lens and camera and with everything shot at an eye-level point of view, while another's vision involves having focal lengths that run the gamut from a full-frame fish-eye to an 800mm, along with the latest version of Photoshop and every possible plug-in needed to make everyone's skin glow like a porcelain doll!

Determining the ways in which you choose to expand your vision and share that vision with others is an ongoing process. Some days you will feel unstoppable in your pursuit, while other days will have you scratching your head, questioning if the visual wizard that was alive and well in you just last week was only a fluke or if he will be returning anytime soon.

For those of you who practice yoga, it's fair to say that at least for your one-hour session you are

very conscious of your breathing. But the minute you step out of that environment, your breathing may return to being simply something you do without any conscious effort. For many, learning to see is much like taking a one-hour yoga class where if you dedicate yourself and put to use the exercises in this book you'll improve your ability to see. But much like breathing, once you are outside of the photographic environment, which is another way of saying you put your equipment away, your artistic vision may also get put aside. It's my belief that just as you can continue to practice your breathing exercises outside of that one-hour class, you can also continue to see without having the benefit of your equipment.

Whether or not your compositions are com–pelling depends not on some magic recipe, but rather on a thorough understanding of lens choice, point of view, elements of design, and, of course, the final arrangement (composition). All of these are like maps, maps that require studying, some more than others. Both your fears and preconceived notions will be challenged. How will you ever share with others the robin's-nest viewpoint as you look down from high in the tree if you're afraid of heights? How will you share the busy sidewalk view when seen from the view of a person's shoes if the idea of lying down on the sidewalk is too intimidating?

You'll certainly hit a "reef" now and then, and you may even feel compelled to abandon ship. This is to be expected. And for that reason, the exercises in this new edition are designed to help you get free of the reef and back on course. There will certainly be times of bad weather or lousy light or limited subject matter, but these exercises will dispel the myth that "there is nothing to shoot."

There's a great deal of material in this book that addresses the what, where, and why of successful image-making. This is a book about ideas—ideas from the river that flows through all of us. It is my intention to help you find the knowledge of where to fish, the courage to cast your net, and the strength to pull in your catch and harvest those ideas.

WHAT IF . . . ?

. . . I had a macro lens and I focused close on those large raindrops on my office window?

. . . I had my wide-angle lens and I placed it on the outer edge of the very busy crosswalk at lunchtime?

. . . I had my telephoto lens and I shot my coworker's portrait during lunch against the out-of-focus background of that really colorful theater marquee?

. . . I focused close on those large yellow flowers in the meadow and gave the world the butterfly's view of the Rockies?

. . . I climbed some stairs at a nearby parking garage and shot down on the throngs of pede-strians crossing the rain-soaked streets with their opened umbrellas at shutter speeds of 1/2 second or 1 second?

. . . I used that broken windowpane as my fore-ground and framed up the solemn-looking boy, baseball bat in hand, in the distance?

. . . I got down low at the edge of a trampoline and captured my son, dressed as Superman, leap-ing high in the air and momentarily stretching out horizontally against a blue sky and white clouds?

If there's one thing my students and peers have taught me over the years, it's that there are no formulas or recipes in the pursuit of image-making. It's all about observation and thought. As Henry David Thoreau once said, "It's not what you look at that matters, it's what you see."

EXPANDING YOUR VISION

HOW DO WE SEE?

I've said it before, and I'm sure I'll say it many times in the future. If my experience as a photographer was purely measured by the exposure times of all the images I've ever made, I would estimate my actual time as a photographer to be just under eight total days. I arrive at this conclusion based on an average exposure time of 1/125 sec. for each of the thousands upon thousands upon thousands of images I have recorded (125 exposures are needed to equal 1 second, 7,500 exposures are needed to equal 1 minute, 450,000 exposures are needed to equal 1 hour, and so on).

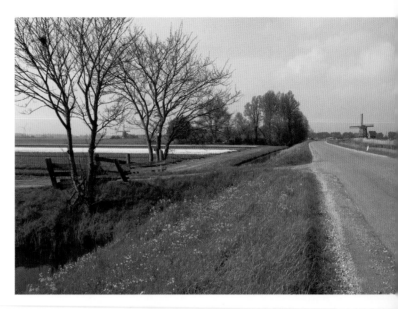

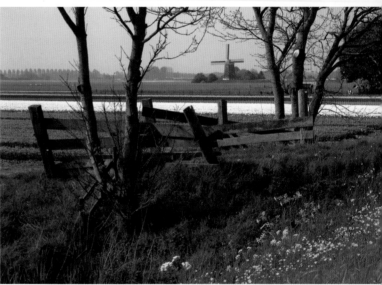

There is, obviously, a lot of down time between exposures, and most of that time is spent doing nothing more than learning to see creatively! I should also add that rarely do I shoot a single image of the "decisive moment." Almost without fail, there is a degree of buildup to that final image, and if you find yourself "chipping away" at your subject with shifts in your point of view or subtle changes in your focal length, welcome to my world! Of course, the degree of chipping away that I do today is less than my first day behind the camera, but every image I've shot has required some degree of fine-tuning. It is this process that helps us learn to see, and learn how we see.

As you are about to find out, the process of learning to see does include an understanding of the technical aspects of photography—i.e., f-stops, shutter speeds, and, of course, the role of light. But to really learn to see, you must have a complete understanding of how your lenses see. When you learn the unique vision of each focal length, combined with various points of view, your ability to see is magnified exponentially. Most of us have no trouble seeing in the conventional sense, but what I'm describing is a unique way of seeing, an ability to make fresh interpretations of the world around you, a world that for most people remains unseen.

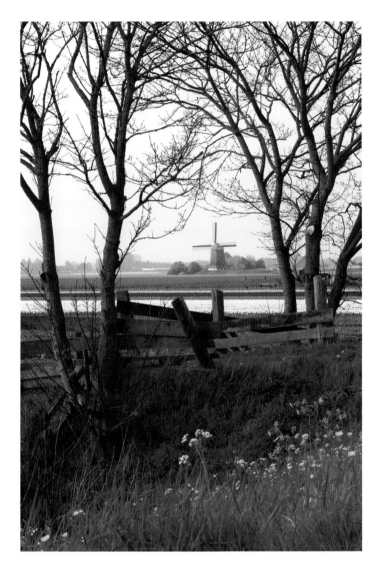

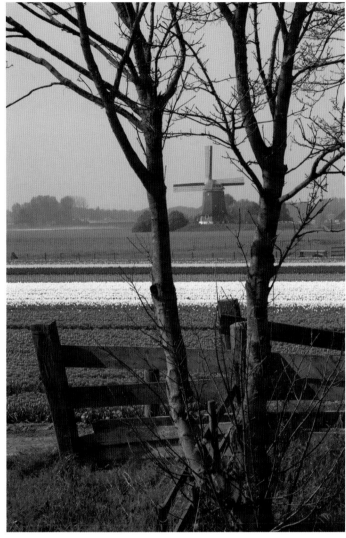

▲ **WE BEGIN** this day's journey in one of my most favorite places in the world, particularly during the month of April, an area called West Friesland in Holland.

I offer a photography workshop there every April, and I was there a day early to get some personal shooting time in beforehand. I pulled my car off to the side of a narrow dike, attracted by the photographic possibilities afforded me by the windmill and tulip field, as seen in this first photo **(opposite, top)**.

With my Nikon D800E and my Nikkor 70–300mm lens on tripod, I soon framed up the one distant windmill and the tulip fields, using both that foreground gate you see along with several trees **(opposite, bottom)**.

Because of the close foreground combined with the distant horizon, I called on a small aperture (f/32), and after adjusting my shutter speed, I discovered that a correct exposure at f/32 would be 1/40 sec. with ISO 200. This same exposure would serve me well in the next photograph **(above, left)**, in which I framed up the same overall scene inside the vertical frame. I moved a bit to the left and included all of the gate, leaving a bit of space on the far left for the gate to "breathe," but I wasn't too thrilled with the horizon line in either this or the next photograph **(above, right)**, as it is running somewhat through the middle of the frame.

continued . . .

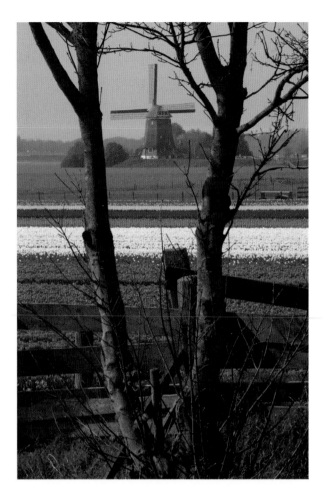

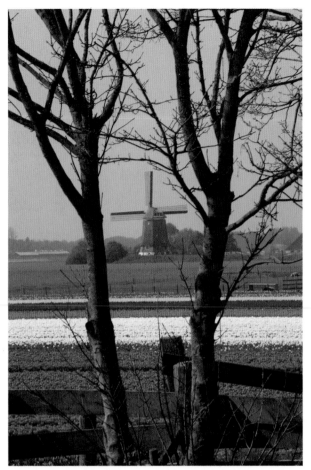

Next I dropped the point of view of my lens **(above, left)**, pushing the horizon to the top third of the image. It still didn't feel right.

I moved closer to the gate in the trees, photographing only the field and the windmill, and as evidenced in the next two photos **(above, right, and opposite, top)**, I only captured the predictable Dutch landscape of a tulip field and the distant windmill.

And then the idea struck me: "Consider the wide-angle possibilities here!" I reached for my Nikkor 24–85 mm "street zoom," and set a focal length of 24mm. When using a wide-angle lens, more often than not my search for the most effective composition will begin with the use of some kind of foreground. When shooting with a wide-angle lens, foreground interest is vital!

I used an opening in the gate **(opposite, bottom)**, getting in close so that the outer edges of the gate formed an immediate foreground frame for the distant field of tulips and windmills on the horizon. However, this very

effective use of foreground framing is not just a simple matter of moving in close to the gate and then framing the field and windmill through this open area; there still remains the need to call upon technical expertise. I'm referring to the need to use the lens's smallest aperture (f/22) and, in this case, turning off autofocus and simply presetting a distance of 1 meter directly above the distance mark on my 24–85mm lens. All that remained was to adjust my shutter speed until 1/100 sec. indicated a correct exposure. Over the course of making these eight images, the light was at times obscured more than at other times, thus accounting for some of the slight exposure variations between these eight images.

My aim on this particular morning was to come away with a landscape—the much larger view, if you will—of the scene before me. Yet I was reminded after the fact that the field of tulips was indeed an oasis of color, texture, shape, and form when seen through the eyes of a macro lens as I looked at another image taken that day **(on the next page)**.

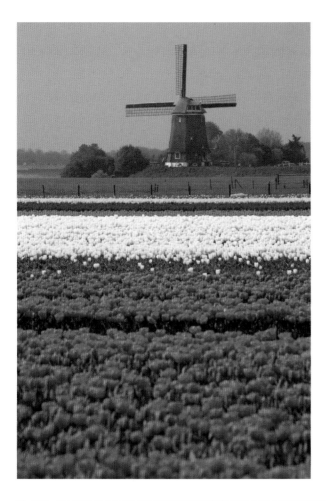

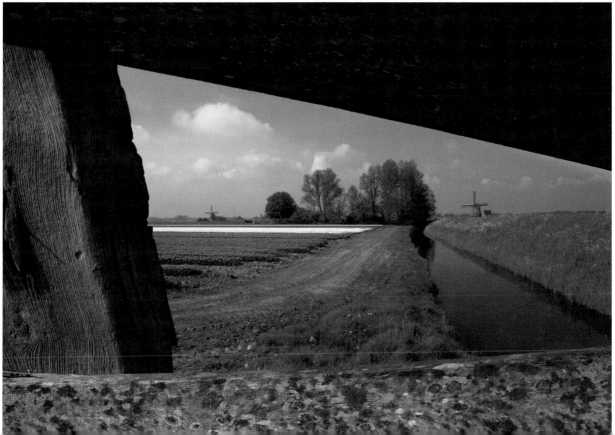

Developing Vision and Creativity

It's fair to say that over forty years of shooting, I continue to chip away at many scenes that I come upon in much the same way that a sculptor chips away at a block of stone. We both look at what lies before us and, in some cases, arrive at the finished product relatively quickly and, in other cases, not so quickly. And to be clear, as I've certainly joked with countless students over the years, the actual formulation of the image (the finished product) occurs, in many cases, in a mere fraction of a second—1/100 sec., as was the case in that last photograph!

As photographers we are faced with problems all the time and as our experience grows behind the camera our responses to some of these very basic visual problems will soon feel second nature—move in closer, fill the frame, turn the camera vertically, use a different lens, open up the aperture, get down low. These responses are what make us better at seeing creatively. Complacency is at times our real nemesis.

This need to "push the boundaries" is what makes a photographer successful. And in combination with a full and complete understanding of PhotoShop and the role it can play in the creative process, any creative endeavor is within reach.

Yes, the title of this book is *Learning To See Creatively*, and learning to see is necessary if you would like to break free from the many visual problems that you will face. But learning to see creatively can truly be learned!

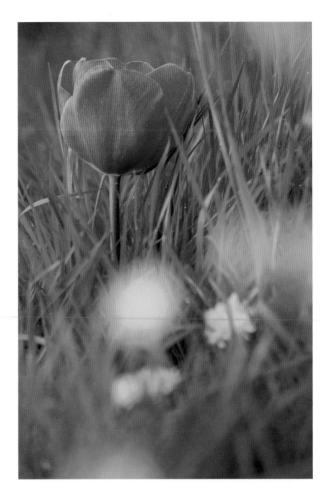

▲ **SUSANA HEIDE,** a workshop student who arrived a day ahead of the workshop, joined me on this particular morning, and she, without hesitation, marched right up to the edge of this field and spent hours shooting nothing but close-up/macro photographs, one of which you see here. I share this with you for an important reason: One of the dangers upon arriving at a given location is falling victim to a singular idea, as I obviously did here—and as did Susana, I might add. My focus on coming away with a large landscape scene made certain that I would return to my vehicle with that sense of "mission accomplished," but it also meant I returned to the car without close-up photographs of the tulips.

Nikon D7100, Micro-Nikkor 105mm, f/4 for 1/2000 sec., ISO 200

HUMAN VISION VS. CAMERA VISION

The human eye sees in much the same way as a 50mm lens, and therefore, the 50mm focal length lens is appropriately called a normal lens. Unlike the eyes of the Six Million Dollar Man, the real human eye cannot zoom out and bring distant objects closer or see the world in fish-eye vision with the flick of a switch. The human eye sees approximately what a 50mm lens sees, since it approximates the "normal vision" of one eye in terms of the overall angle of view, 38 degrees. With both eyes open our vision is akin to the 75-degree angle of view of a 28mm wide-angle lens.

In photography's early years, much if not all of the picture-taking was done with normal lenses. Of course, a lot has changed since those early days. There now exists a proliferation of single-focal-length lenses, ranging from a full-frame fish-eye to a whopping 2000mm telephoto, and an almost equal number of variable zoom lenses. In addition, there is also the fascinating world of macro, or close-up, photography.

In my early years as an amateur photographer, I had nothing more than a 50mm lens and a Nikon camera body. Financial reasons kept me from buying an additional lens for quite a while. Finding myself in the position of owning just one lens, I soon realized the need to physically walk closer to my subjects to better fill the frame. I also learned how changing my point of view could invoke a greater sense of participation with my subjects when I met my two-year-old cousin at her eye level as I followed her around the backyard. After climbing a large cherry tree, I discovered a new and exciting close-up view of the robin's nest with blue eggs before me and the far-reaching landscape stretched out below. It wasn't long after that one experience that I began climbing even taller trees and shooting down on numerous nature-filled landscapes. Perhaps this need to climb trees was an attempt to redeem myself from the fall I took out of a twenty-foot fir tree at the age of three!

I also have a vivid memory of the first time I looked up with my 50mm lens. After spending most of one morning shooting autumn leaves on the ground in a large aspen grove, I decided to take a break. While lying on my back, I reached for my camera just to take a look at the canopy of trees and blue sky overhead. My need for a break ended immediately! Later, I even learned that I could render a background of muted and out-of-focus color simply by focusing as close as possible and using the biggest lens opening. Little did I realize back then just how valuable these lessons were.

In my on-location workshops and in my online photography courses, it continues to be apparent that most students are not familiar with the inherent visions that lie within their complement of lenses. As far as I'm concerned, the only—and the quickest— way to expand one's vision is by doing the necessary "eye exercises." Having now read about a few various lens choices and points of view, try the following exercise, which always proves to be revealing to my students.

⬡ EXERCISE : Knowing What Your Lenses See

Every serious photographer, from beginner to pro, speaks of creating a "vision." And just how do you achieve the vision? In large part, by knowing what your lenses see. Making the most of your camera bag is, in many respects, like speaking a foreign language; unless you are willing to learn the language of your lenses, you won't be speaking with them—let alone be able to understand them.

Chances are very good that you have one of those "street zooms"—i.e., 24–105mm, 24–85mm, 18–200mm. To be clear, a "street zoom" was initially a reference to a lens that offered a moderate wide-angle and a moderate telephoto vision, such as a 35–70mm, but now, due to advances in the photographic industry, a street zoom could easily be a 28–300mm. The term itself is derived from the desire of many photographers to walk around the streets with an "all-purpose" lens and thus the name "street zoom" was born.

Depending on your lens type, set the focal length to the widest setting (18mm or 24mm) and make a point to not change this at any time during this exercise. Now choose a subject (a favorite barn or oak tree) or take your spouse, friend, or child into the backyard or over to the local park. Place your subject in the middle of the frame, allowing for a lot of empty space above, below, and to both sides. With the camera still at your eye, make your first exposure, and then begin walking toward your subject. Every five paces, take another exposure, being mindful to keep the subject in focus. Keep walking closer until your lens can no longer capture the subject in sharp focus.

One thing is sure to result from this exercise. Your first composition will record not only your main subject but other stuff that probably detracts from it, and your final composition should record a close-up of your subject, which not only cuts out that other stuff but maybe cuts out some important stuff, too.

Now, without changing the focal length, repeat the exact same exercise while on your knees and then again while on your belly. Finally, once you've gotten as close to your subject as you can, and making that last shot while on your belly, turn over onto your back and take just one more shot while shooting straight up.

While walking on your knees, you no doubt discovered a far more intimate portrait of the small child. (And if you try this exercise with a landscape scene, perhaps you'll record a far more intimate "portrait" of that barn with the added drama of depth and perspective since whatever surrounds it fills up the foreground.) Perhaps, while on your belly, you discovered a wonderful and fresh composition of the surrounding park framed through the feet and lower legs of your friend or spouse. And most of all, you learned the inherent vision, when combined with differing points of view, of your lens.

But you've only just begun! Make a point to do the same exercises at 50mm, 60mm, 70mm, 80mm, 90mm, and 105mm. If you maintain this regimen of "eye exercises" once a week for three months, you'll have a vision that is shared by fewer than 10 percent of all photographers, and it will be a vision that gets noticed. At that next on-location photography workshop, you won't be in that group of students wandering around uncertain about what lens to use. Once you've integrated the vision of your lenses into your mind's eye, you can stand at the edge of a meadow or lake and scan the entire scene, picking out a host of compositions even before you place the camera and lens to your eye.

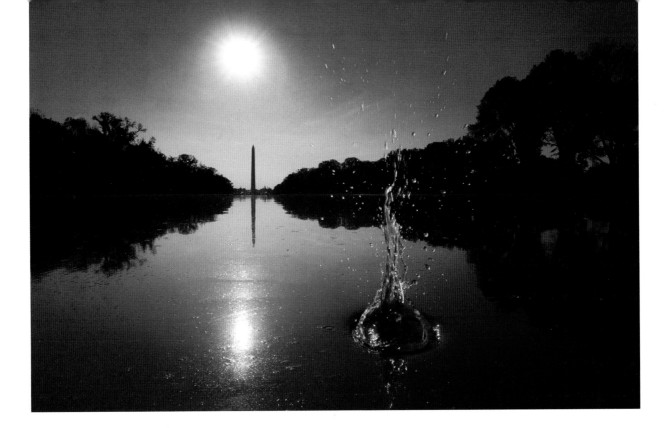

LENS CHOICE

Why does lens choice matter? If we think of the subject we wish to shoot as the noun and lens choice as the adjective, it might become clearer. Yes, you have a "pretty" scene before you, but with the right lens choice that same "pretty" scene may soon look "magnifique" or "awesome" or, heaven forbid, "blasé." Lens choice, more than anything else, will determine if your viewer understands both the content and the intent of the overall composition. For obvious reasons, not all compositions are deserving of the same adjective, which is why you have various focal lengths (i.e., lots of adjectives in your bag).

▲ **ONE OF** the constant challenges every photographer faces is coming up with a fresh viewpoint for tired and worn out subjects. The reflecting pool at the base of the Lincoln Memorial is a familiar composition. But what if I dropped a small stone into the pool?

Opting for the wide-angle lens, I was quick to recognize that I would need both a large depth of field and an action stopping shutter speed of at least a 1/250 sec. So, with my ISO set to 400, my aperture set to f/22, and my focus set manually to one meter, I adjusted my shutter speed until a 1/320 sec. indicated a correct exposure as I aimed the camera into the strong backlight you see here. With the camera on tripod and one hand on the shutter release, I threw the rock up in the air and took three shots in rapid succession with the camera set to CH (continuous high speed firing). I produced *one* winning composition. All of the blue you see here is not because I used a filter but because I chose to use a white balance of incandescent/tungsten which will always turn a daylight scene into a "moonlight blue."

Nikon D800E, Nikkor 24–120mm at 24mm, f/22 for 1/320 sec., ISO 400

Wide-Angle Lenses

Literally, the wide-angle lens is the only lens capable of expanding your horizons, and it can do so in a dramatic fashion. The chief advantage of the wide-angle lens can also be its chief disadvantage; it makes distant subjects even smaller, but in doing so, it opens the door to emphasize that large blooming barrel cactus in the immediate foreground. And it does this with the most massive depth of field of all lenses; in some cases sharpness from 7 inches all the way to infinity, something you will never have with a telephoto lens! As experienced wide-angle photographers know, this is a case of the wider, the better. There are, in my opinion, two wonderful extremes that only the wide-angle can create, and they are chiefly the same two reasons why I call upon it often: (1) a dramatic exaggeration of foreground object size (when you make certain, of course, to include distant objects to bring a sense of scale to an image—e.g., the red barn on the horizon when photographing up close the red strawberries in the strawberry field), and (2) an emphasis on an interesting sky (when composing so that almost three-quarters of the composition is sky and you, in turn, "humble" that red barn on the horizon below). Used creatively, with at least these two ideas in mind, the wide-angle lens will never disappoint!

The odds are quite strong that if you were to ask any newspaper or *National Geographic* photographer what his or her favorite lens is, "a wide-angle" is what you would probably hear, "a wide-angle" zoom to be more precise. These types of photographers have stories to tell, and these stories are often told by either a single image or a small collection of images. Most of these are shot with wide-angle lenses, because those lenses are all encompassing and, as a result, do tell a great story.

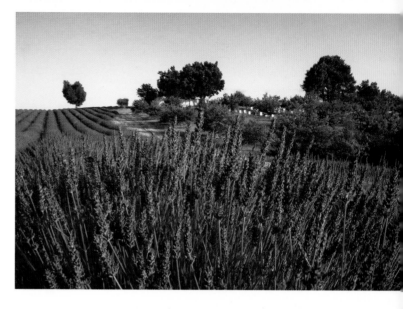

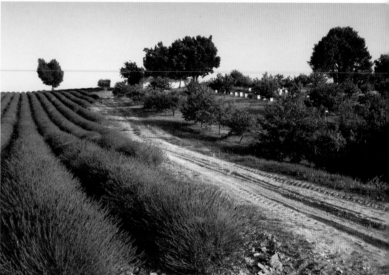

▲ **AS YOU** look at these two photographs side by side, it becomes apparent that the first image **(top)** evokes a greater sense of intimacy. The use of what I call an "in-your-face foreground" is responsible for this. You get a sense that this might be the honeybee's view as it makes its final approach to the awaiting lavender flowers. The second composition **(bottom)** is in marked contrast to this. In fact, all things being equal, the honeybee, on seeing this view, might think it still has some distance to travel, being a bit too far from the final destination to actually smell the flowers or feel their texture. I use this analogy for a very good reason: our reaction to photographs made with a wide-angle lens but without immediate foreground interest is often one of indifference.

Both photos: Nikon D800E, Nikkor 17–35mm lens at 17mm, prefocused to 1 meter (autofocus off), f/22 for 1/20 sec., ISO 200, polarizing filter

▼ **ONE OF** the complaints from amateur photographers about the wide-angle lens is its tendency to include too much subject matter. While conducting a workshop in Tucson, we came upon a graphic arrangement of mailboxes. While a student ran through the frame, we photographed her at 1/30 sec. to get the desired subtle blur of her movement.

Despite several students' insistence that they were including immediate foreground interest (i.e., mailboxes), they were quick to complain that the entire composition was simply too cluttered, too busy. I agreed, emphatically—see example **(right)**!

Lying down next to the base of the mailboxes proved to be the one viewpoint that eliminated the busy background while including more than enough of the expansive blue sky and white puffy clouds to allow for some welcomed contrast as our model ran through the scene **(below)**. Lying on your back, your side, or your stomach will soon become second nature as you discover the effectiveness of these low points of view. Note, too, that I used a polarizing filter here to accentuate the sky and white puffy clouds.

Both photos: Nikon D800E, Nikkor 17–35mm lens at 17mm, f/22 for 1/30 sec., ISO 200, polarizing filter

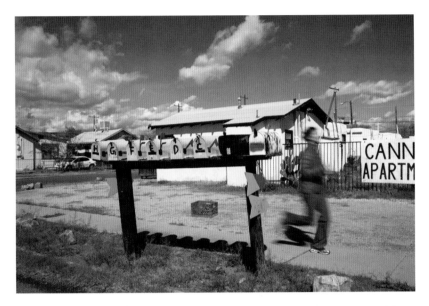

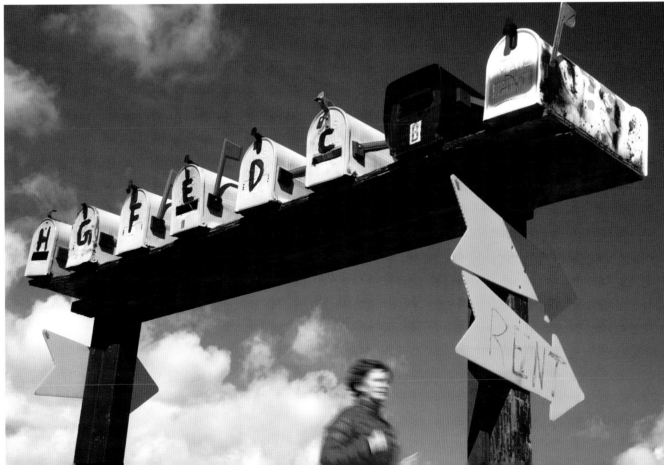

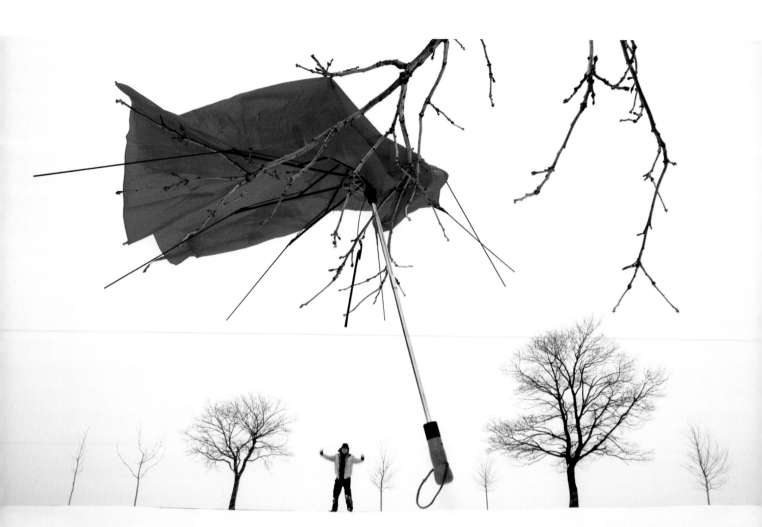

▲ **I'VE LIVED** in Chicago for the past five years now and I have yet to experience a winter when I wasn't dreaming of the summer to come as early as November.

Yet, if not for the brutal Chicago winters, I could not lay claim to some of my favorite images. This is one of those shots.

Along Lake Shore Drive, there's a long and winding bicycle and jogging path. Only following a fresh snowfall does the utter starkness of this landscape become apparent. Braving temperatures that were well below zero, I ventured out with a red umbrella that had suffered extreme wind damage just the day before. I placed it securely in a low-hanging tree branch, mounted my camera securely on tripod and framed up the red umbrella in the upper portion of the frame. With the camera's self-timer set to fire the shutter release following a 10-second delay, I quickly ran into the snowy landscape beyond and, during the brief exposure, acted as you might if you experienced a voracious blast of Chicago wind snapping your umbrella from your hands and depositing it in a tree.

Nikon D800E, Nikkor 24–85mm lens at 24mm, prefocused to 1 meter (autofocus off), f/22 for 1/20 sec., ISO 100

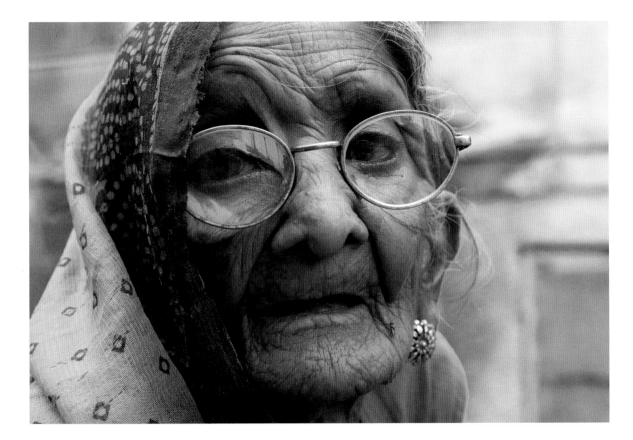

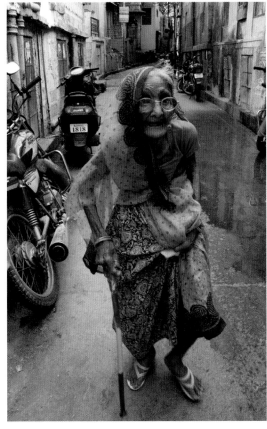

▲ **AS I** ventured out in Jodhpur, India, the morning I made this image, I had only my all-purpose Nikkor 24–85mm lens and camera body. No one has to convince me that leaving behind most of my gear every once in a while is liberating, and this morning was no exception.

Walking down one narrow street, I saw an elderly woman coming my way and soon was photographing her at the 24mm focal length as she walked toward me **(left)**. I hadn't fired off more than five frames when she stopped and made it clear that I was blocking her path. I seldom photograph complete strangers, so I backed off. Just then a young boy passed and the elderly woman said something to him that caused him to stop and say to me, "She wants to know why you are taking pictures of her?" I was quick to say that I was simply a student of photography and that I felt that both she and the

small street on which she was walking conveyed just the right amount of "stuff" to tell a story about daily life in Jodhpur. He translated this for her, and I quickly asked him if he could ask her to allow me the honor of shooting a simple portrait of her face against the background of the blue walls—and although I don't speak Hindi, I could tell by her intonation that she was saying, "Okay, but make it snappy!"

Despite the intimacy of this portrait **(above)**, it's not the all-encompassing wide-angle lens that's usually used for detail; it is the telephoto lenses (85mm through 400mm), which we will discuss shortly, that are often called upon to show the details of the world that surrounds us.

Left: Nikon D800E, Nikkor 24–85mm lens at 24mm, f/11 for 1/100 sec., ISO 200

Above: Nikon D800E, Nikkor 24–85mm lens at 85mm, f/5.6 for 1/640 sec., ISO 200

▶ **THE WIDE-ANGLE** lens is noted for its ability to exaggerate many things, but perhaps, its ability to exaggerate the actual size of a small puddle of water is its greatest "lie." Anywhere there's a reflection, there exists the potential for the wide-angle lens to exaggerate the story that is about to unfold.

While conducting a workshop in Old San Juan, Puerto Rico, I noticed a very small rain puddle. We had hired several young models for this particular morning's shoot, and I felt the need to use the rain puddle as an opportunity to exaggerate the foreground interest. With my lens set to a focal length of approximately 22mm, I was able to record a mirrorlike reflection of the model and the surrounding nearby buildings in the puddle **(opposite)**. In addition to a focal length of 22mm and aperture of f/22, I used a 3-stop Lee soft-edge graduated neutral-density (ND) filter after first setting my exposure for the lower half of the composition you see here. The difference between the lower half of the scene and the much brighter upper half was almost 3 stops, which is why I needed the 3-stop graduated ND filter. Do not attempt to set an exposure for the scene after placing the filter on your lens; rather, first establish your exposure without the filter and then place it on your lens.

Opposite: Nikon D800E, Nikkor 17–35mm lens at 22mm, prefocused to 1 meter (autofocus off), f/22 for 1/30 sec., ISO 200, 3-stop graduated ND filter

USING LIVE VIEW

If getting down low on your belly to line up a shot like the one opposite is difficult, then you might want to consider falling to one knee and calling on your camera's Live View. Live View is a function on most DSLRs that allows you to have a "live view" of what is going on inside your viewfinder, but instead it is being played out on your camera's monitor and thus the need to get your head and eyes up close to the viewfinder is eliminated. If you are not sure how to turn on Live View, consult your camera manual.

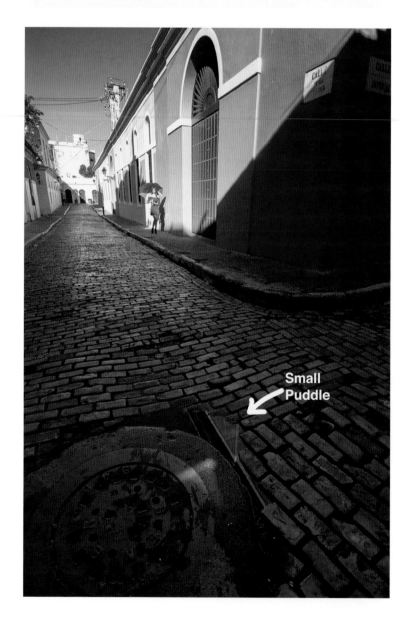

Small Puddle

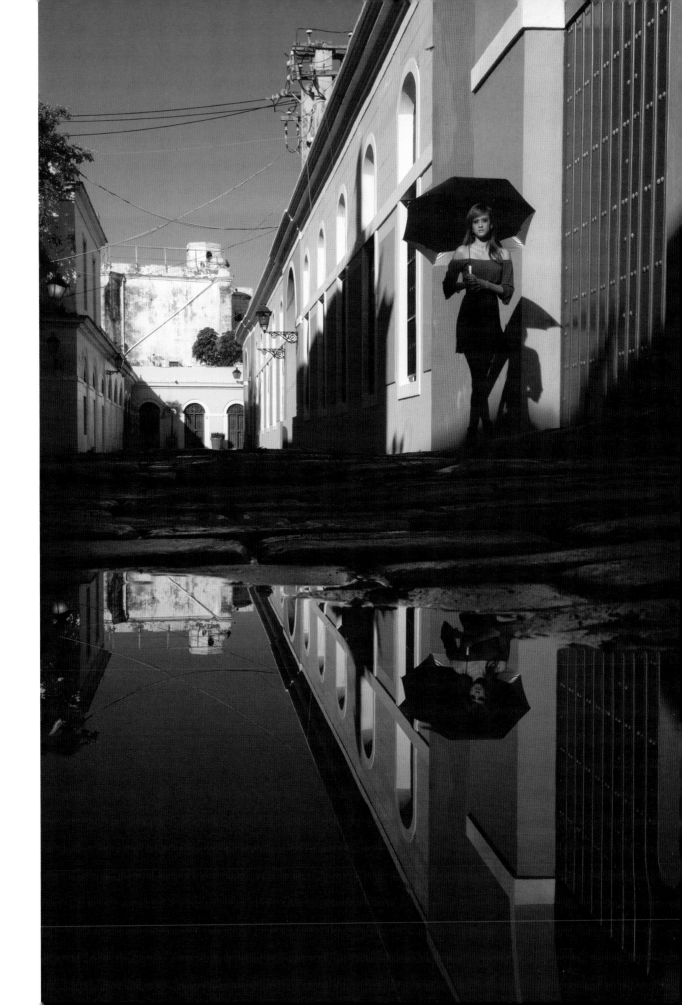

Full-Frame Fish-Eye Lenses

Due to its curvilinear perspective, the full-frame fish-eye lens is unmistakable for the strong curving horizon lines or the stretched-out rubber-like faces it produces. Most photographers who buy a fish-eye lens do so because of the very positive experiences they've had with their wide-angle lens or wide-angle zoom lens. Their experience shooting with their wide-angles has taught them that the distortion they sometimes record is very dramatic. An example of this would be lying down in the forest and looking straight up through tall trees, resulting in a feeling of tremendous depth and, of course, the bending of the many vertical lines. So it's not a big leap to push this idea even further and go for even stronger, more dramatic, and more exciting wide-angle images with the purchase of the fish-eye. The fish-eye lens, perhaps more than any other, gets very little use beyond landscape photography by most shooters, and it's my belief that if you went out the door with just a fish-eye and made a point to look at any non-landscape subject, you would return at the end of the day with quite a number of spoils from the hunt!

To have success with the full-frame fish-eye lens beyond landscapes, you must make it a point to get in so close, at least initially, that the lens is within a cat's whisker of the subject. Most super-wide-angle lenses will focus down to as close as 7 to 9 inches, but a full-frame fish-eye lens will easily focus to within 3 inches and at an angle of view that is anywhere from 130 degrees to a full 180 degrees, depending on the make and manufacturer. The closer you focus and in turn tilt the lens up or down will determine to what degree the "fish-eye" effect is magnified. The more you tilt up or down, the greater the degree of "fish-eye" effect on your subject. And if you're shooting the scene before you at the small aperture of $f/22$, you'll soon be recording foreground sharpness within 1 or 2 inches of the lens!

▶ **DURING A** trip to Holland, a young farmer invited me to see his 120-stall milking barn and photograph his many black-and-white milking cows. Since it has been years since I gave up my farm in Oregon, it had been a long time since I was afforded any opportunity to photograph a group portrait of cows.

The full-frame fish-eye is so predictable in terms of its look that it's sometimes not even necessary to place the camera and lens up to your eye; rather, you can simply stick it out in front of you, which is what I did on this particular afternoon, knowing that I was framing up fish-eye group portraits of the cows. This image has quickly marched into my all-time top ten pictures that I've made throughout my entire photographic career. Although I don't use the adjective that often, I can only describe this image as truly endearing.

Above: Canon 5D Mark II, 24mm lens, $f/8$ for 1/640 sec., ISO 100. Photo by Susana Heide

Right: Nikon D800E, Sigma 15mm full-frame fish-eye lens, $f/13$ for 1/200 sec., ISO 100

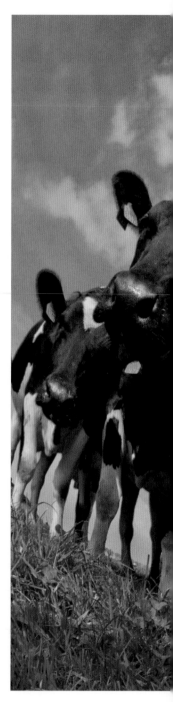

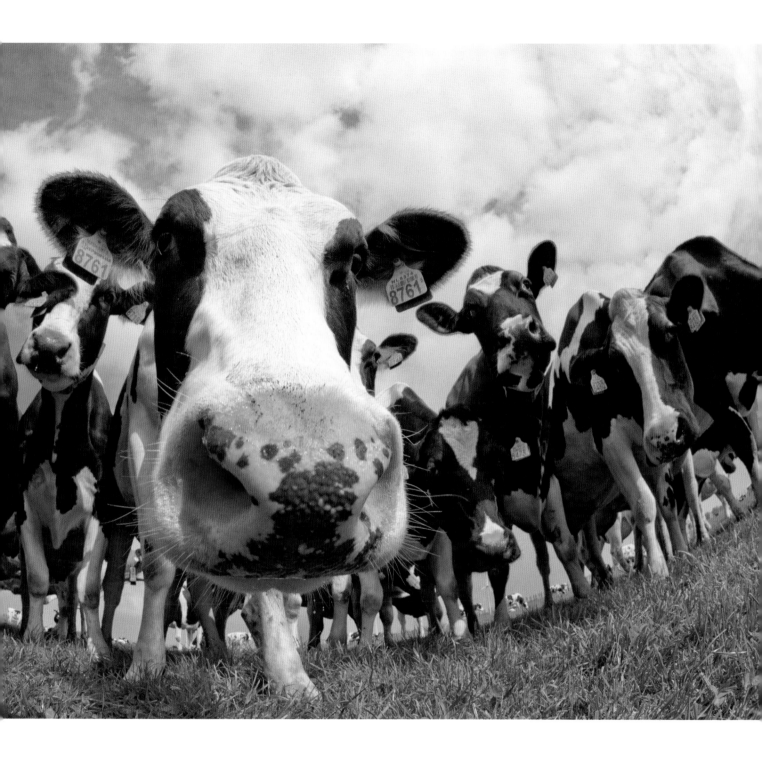

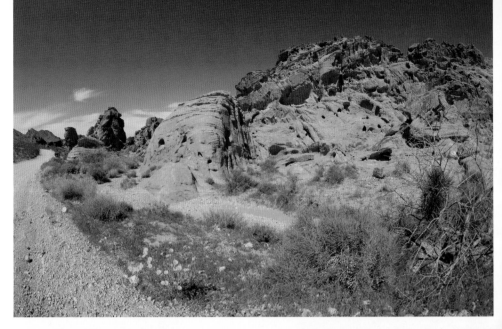

▶ **OF OUR** many subjects while in Las Vegas and the surrounding area during a recent workshop, none was more formidable than Valley of Fire State Park. I didn't even come close to shooting the many potential compositions that this park offered up, but what I did manage to shoot on one particular afternoon was a fish-eye composition of flowers and red rocks.

Pulling the van off to the side of the road, I decided to take on the smallest patch of yellow blooming flowers, and showcase them against the stark contrast of the red rocks and blue sky in the background. This kind of exercise was really a simple one, since all it asked was that I be so close that the yellow flowers were within a cat's whisker of touching the front of the lens. Once that happened, I backed off just enough so that all the flowers were included and made slight up-and-down and side-to-side movements while looking through the camera to make certain that nothing unwanted was showing up in my frame.

With my aperture set to f/22 and focus set on the flowers, I adjusted my shutter speed until 1/60 sec. indicated a correct exposure and simply fired off several frames.

Both photos: Nikon D800E, Sigma 15mm full-frame fish-eye lens, f/22 for 1/60 sec., ISO 100

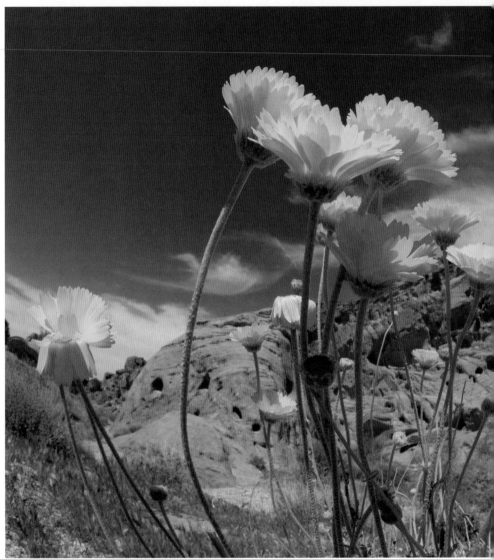

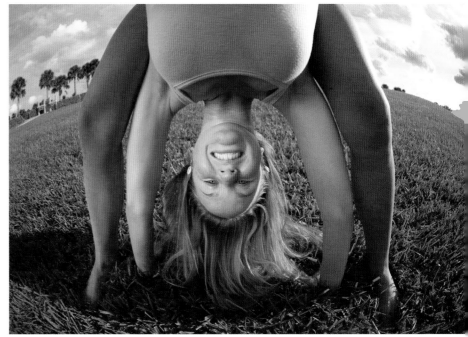

▲ **IF I** were to choose one photograph in this book that might cause some disruption in your perception of reality, this shot would probably be the one. Your initial impression, like that of most people, is that this girl is extremely flexible, but you are quick to come to the realization that something is amiss here. What began as a simple idea of capturing the young woman doing a headstand soon became the disorienting composition you see here. The subject was having difficulty maintaining her balance, and so her close friend came in to hold her legs straight up. It was then that I realized there was an opportunity here to play with the mind. So what we're really looking at is a photograph of two people, the legs belonging to one of the young women and the arms and face belonging to the other.

Nikon D300S, Nikkor 10.5mm fish-eye lens, f/16 for 1/60 sec., ISO 100

Street Zooms

If there's overwhelming evidence of changes in the photo industry, it would be in the area of what I call "street zooms." Twenty years ago, in an effort to walk the streets with a camera and a single "all-purpose" lens, I almost always found myself with my Nikkor 35–70mm F2.8. That was eventually replaced by a Nikkor 24–85mm F2.8–F4 and then, briefly, the 24–120mm F4 before I returned to the 24–85mm since I wasn't happy with the overall sharpness of the 24–120mm. Only last month did I again replace my street zoom with what I feel is an even sharper, albeit "slower," version of the 24–85mm F2.8–F4: the new 24–85mm F3.5–F4.5G ED lens.

I define a street zoom as a lens with a relatively modest telephoto range and a somewhat wider-than-normal 28mm range. If the lens also includes some degree of macro/close-focusing capabilities, then that's simply a plus. If I were resigned to a single lens, I would opt to go around the world with this current 24–85mm street zoom.

No doubt you are familiar with other street zooms: the 18–55mm, the 24–70mm, the 24–105mm, the more popular 18–200mm, or the even "bolder" 28–300mm. Yes, we are becoming increasingly closer to achieving the truly all-purpose lens that promises to cover 90 percent, if not 100 percent, of one's shooting needs throughout the year. I don't recall exactly when I said it, but I do recall saying, somewhat tongue-in-cheek, that I will be the first in line to purchase the 4-inch-long 20–400mm F2.8 lens with macro capability. Now before you get in line behind me, rest assured that this lens doesn't yet exist. If I had full control over the entire photographic learning process, no photographer would have access to any lens other than a 24–85mm for the first twelve months of learning. And if beginning photographers would spend no less than twenty hours a week walking the streets with that lens, odds are extremely high that after one year they would probably not be rushing to buy another lens! There isn't that much out there in the world that you cannot shoot effectively with the 24–85mm. And for what it's worth, most award-winning images worldwide have been shot at focal lengths between 24mm and 85mm. It really is amazing what you can do with a "street zoom."

PREPARING FOR A PORTRAIT SHOOT

Portraits, candid or posed, can often be some of the most fulfilling images we ever take, but the act of shooting a "simple portrait" can send shivers through some, especially if the subject is a stranger. Unlike flowers and landscapes, people can and do react to the photographs you are taking of them. Assuming you want the reaction to be favorable, I suggest determining your lens choice and exposure ahead of time if possible. If you are planning on using some kind of background, seek it out before looking for subjects to place in front of it.

Every portrait studio has at least several different-colored and/or -textured backgrounds. I would never have clients come into my studio and then ask them to wait on me while I stood there trying to decide which background(s) I should use for their upcoming portrait session. Their time is valuable, too! Likewise, when shooting portraits in the great outdoors, I seek out potential backgrounds before looking for willing subjects.

▼ **COMING UPON** a wagon stacked with orange bags of rice in Delhi, I knew that I had a great background—clean and obviously colorful. The search was now on for a willing subject, of which the Chandni Chowk district has no shortage. Within minutes, I was soon photographing the man you see here.

Below: Nikon D800E, Nikkor 24–85mm lens at 55mm, *f*/11 for 1/60 sec., ISO 200

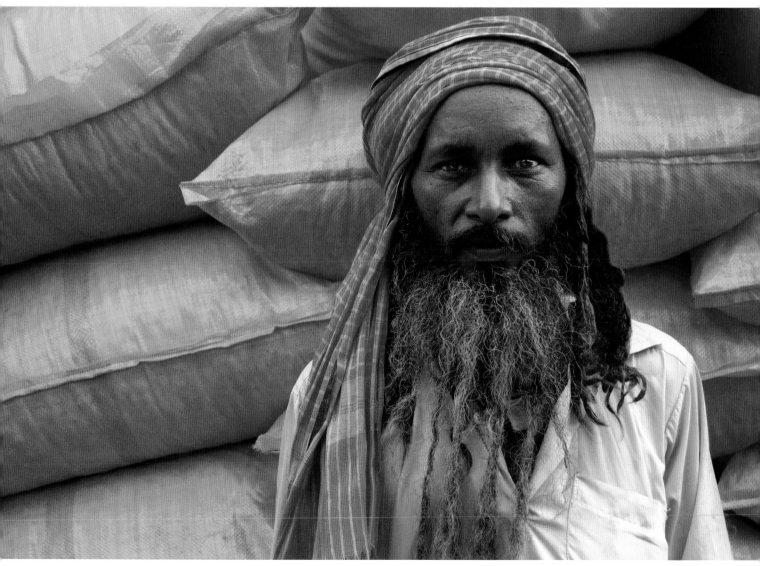

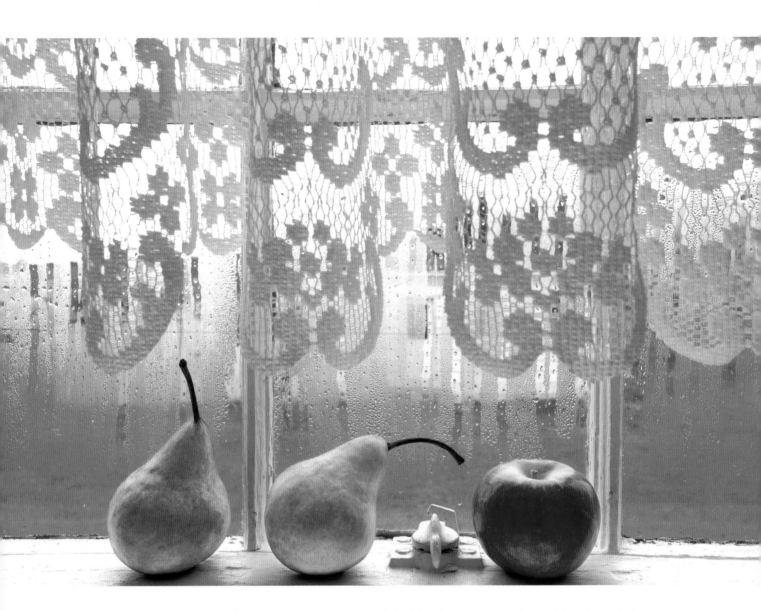

▲ **EVERY PHOTOGRAPH** you and I have ever made has some kind of story behind it, short or long as it might be, and some are more memorable than others, as is the case with this image. I had arrived in Peggy's Cove, Nova Scotia, where my good friend Roger has a home and where I would be conducting a workshop. On this particular trip, I was staying in a Cape Cod–style house on a small bluff looking straight out at the rocky beach.

The first morning, I hadn't taken more than two steps out of bed when I felt the sensation of extreme cold. When I saw my breath, I realized just how cold it was inside the house. I realized I hadn't turned on any of the heat, and coming down stairs into the kitchen, I was quick to notice a great deal of condensation on one of the kitchen windows that was partially covered with a lace curtain. It proved a wonderful distraction from the cold, as over the course of the next

twenty minutes I found myself shooting a number of exposures of this window with several pieces of fruit I had taken from a nearby fruit bowl. It's fair to say that sometimes we photographers can become so focused that we are able to forget about the "hardships" that may surround us!

Nikon D800E, Nikkor 24–85mm lens, *f*/11 for 1/60 sec., ISO 100, gold reflector

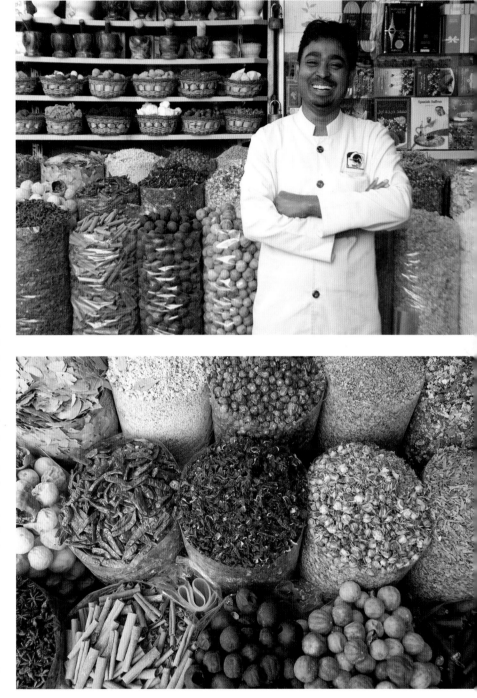

▶ **I'VE ALWAYS** enjoyed going to the Spice Souk in Dubai, for two great reasons: (1) a chance to photograph some really wonderful people, and (2) to be doing so while the smell of numerous spices fills the air.

Although it was a brief initial conversation, my request to photograph this vendor in front of his shop was met with an enthusiastic response. With my camera and 24–85mm lens, I was quick to frame up the shot you see here **(top)**.

Several minutes later, after exchanging email addresses and making the promise that I would email him several images, I also shot the patterned composition of spices seen behind him **(bottom)**. To make this shot, I again called upon the multitalented vision of the 24–85mm and simply raised the camera up slightly above my head and shot straight down. Shooting in this fashion, when looking through the viewfinder is not possible, is sometimes a hit-and-miss proposition, but after a few frames, I got the composition I wanted.

Both photos: Nikon D800E, Nikkor 24–85mm lens, f/8 for 1/125 sec., ISO 200

Telephoto

If we think of the wide-angle as the all-encompassing storytelling lens, then it is fair to say that the telephoto lens is the one we use to add that often-elusive exclamation point! By design, the telephoto lens has a much narrower angle of view, forcing you to focus your vision. In addition, the telephoto can keep your feet dry as it reaches across the small stream and allows you to focus on that large flower growing along the stream's edge.

Telephotos are also known for their shallower depth of field and thus their ability to be the go-to lens for shooting portraits, since you can fill the frame without invading the subject's space and keep the background muted or out of focus at the same time so that nothing distracts the eye from the subject. Yes, there are many telephoto lenses available, but for most everything, including some wildlife photography and trips to the zoo, the telephoto zooms that reach all the way to 300mm are my personal favorites.

As compared to the 24mm focal length and its 84-degree angle of view, the far narrower angle of view of 11 degrees is reason enough to seldom reach for the 135mm telephoto to tell the story, since its vision is forever trying to call your attention to the details in those all-encompassing compositions taken with the 24mm wide-angle. But the narrow angle of view brings subjects closer, which in some cases is a good thing (e.g., we remain safe behind the fence while recording a frame-filling composition of a lion sunning itself on a large rock at the zoo).

As is often the case when using the wide-angle storytelling lenses, you'll use the very small aperture of f/22 to tell the most effective story. But with the telephoto lenses, you'll often use the much larger apertures of f/2.8, f/4, or f/5.6 to emphasize the "exclamation point" you're seeking. These large lens openings result in some very shallow depths

of field, and because of this, you can look for ways to "wrap" your subjects with areas of out-of-focus colors and shapes, further emphasizing that one very sharp exclamation point. I routinely seek out subjects that, when deliberately thrown out of focus, help call greater attention to the area that's in focus.

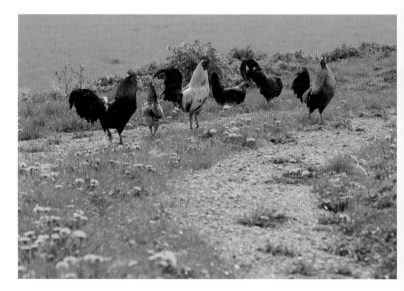

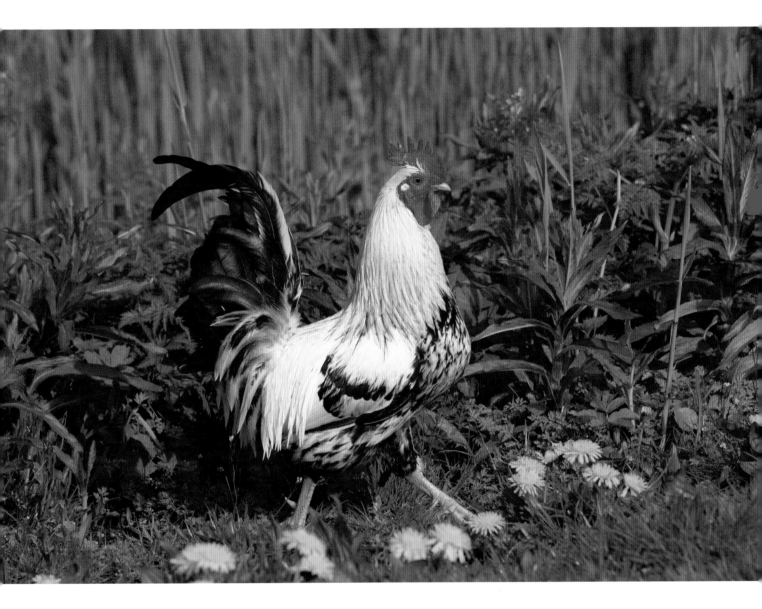

▲ **DOMESTIC OR** wild, many animals are not as approachable as we'd like, so we must resort to using the telephoto lenses if we wish to record a frame-filling composition. Coming upon a group of roosters, I was determined to record at least one "portrait" of one of these fellas, and after switching to my Nikkor 70–300mm lens, I began stalking one. Against the grassy backdrop of a colorful spring, I was able to catch him in stride, all thanks to the 300mm focal length! It's an easy frontlit exposure here, and yes, you could shoot this in Aperture Priority mode if you wish, but old-school me chose to shoot it in manual exposure.

Both photos: Nikon D800E, Nikkor 70–300mm lens, f/6.3 for 1/800 sec., ISO 50

▶ **ANOTHER GREAT** excuse to use the telephoto lens is to take a very "splashy photograph" without ever getting wet. I was visiting my brother in Seattle on a hot August day, when his grandson Tyler and a neighbor, Cruz, decided to have a water fight. I immediately saw the photo opportunity and was soon directing their every move. Yep, another example of me being guilty of "staging" a photograph.

This was a relatively easy shoot to direct: "Hey, Tyler, set the nozzle of the hose to the high-pressure spray setting, and Cruz , put up your hand, blocking the spray in much the same way Superman blocks the dreaded ray gun." And while this scene unfolded before me, I was quick to frame up both a horizontal and vertical composition, placing all of my focus on Cruz's hand.

As you look at both compositions, notice that the visual weight (the area of focus) is very narrow, limited to Cruz's hand. This was the result of using a very large lens opening of f/5.6. And when using this large of a lens opening on a sunny day such as this, I'm always guaranteed a very fast shutter speed.

All photos: Nikon D800E, Nikkor 70–300mm lens, f/5.6 for 1/1,600 sec., ISO 200

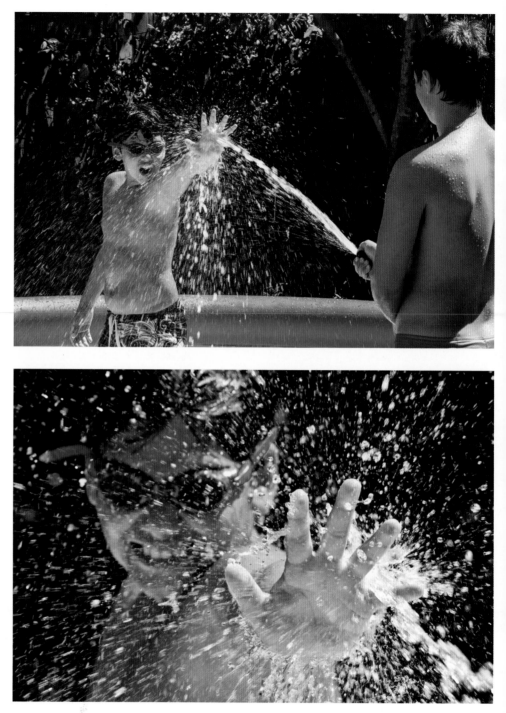

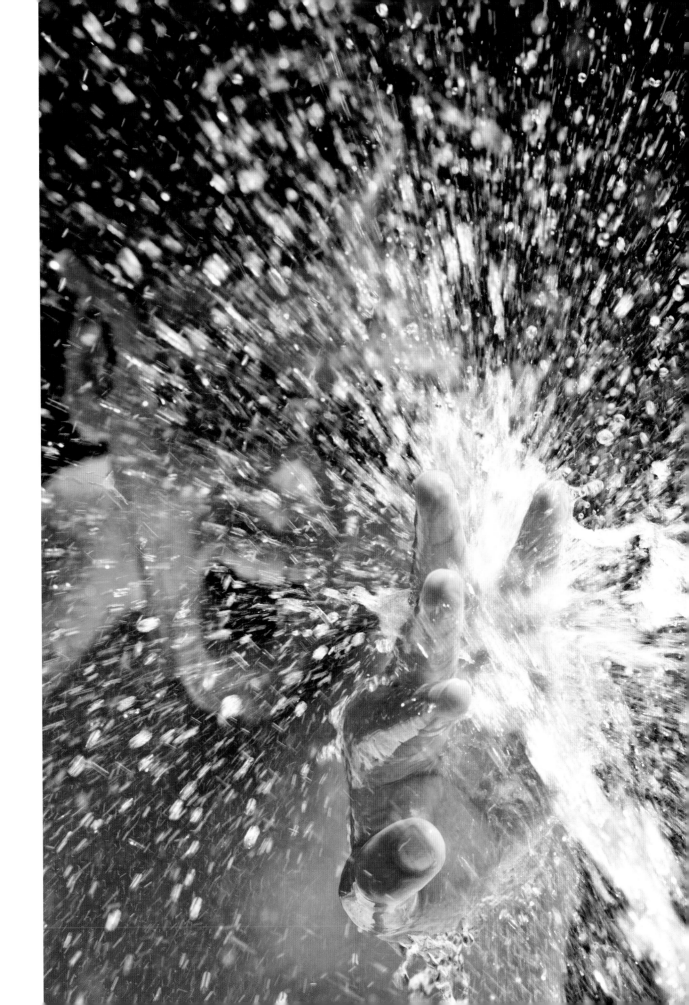

▼ **A TELEPHOTO** lens was the only choice when making this detailed composition of several bags of goldfish being sold at a fish market in Hong Kong.

One of the unique aspects of this photographic opportunity was the contrast between the foreground bags of fish and the much darker background. With my exposure set for the brighter sidelit bags of fish and a point of view that placed the bags of fish against that dark painted background, I got the contrast you see here.

Bottom: Nikon D800E, Nikkor 70–300mm lens at 270mm, f/11 for 1/250 sec., ISO 100

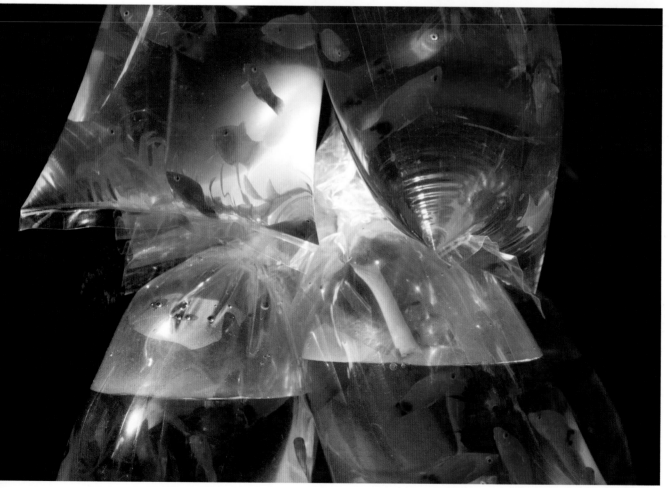

▶ **THE FIRST** time I shot in the wine country of Beaujolais, France, was the most colorful I ever witnessed it. Although I arrived at this vineyard about a week later than the harvest, there were fortunately a few missed clusters of grapes still hanging from the vines. The few clusters I found, however, were *not* surrounded by the beautiful and colorful leaves. So I carefully placed about seven to nine leaves back up on the vines until my lone cluster was now surrounded **(below)**, and with my camera mounted on tripod and my 70–300mm lens zoomed out to 240mm, I quickly arrived at a frame-filling composition. All that remained was to keep the aperture wide open so that the leaves that were *not* in the narrow plane of focus would record as out-of-focus tones of color.

Right: Nikon D300S, Nikkor 70–300mm lens at 240mm, f/4.5 for 1/200 sec., ISO 200

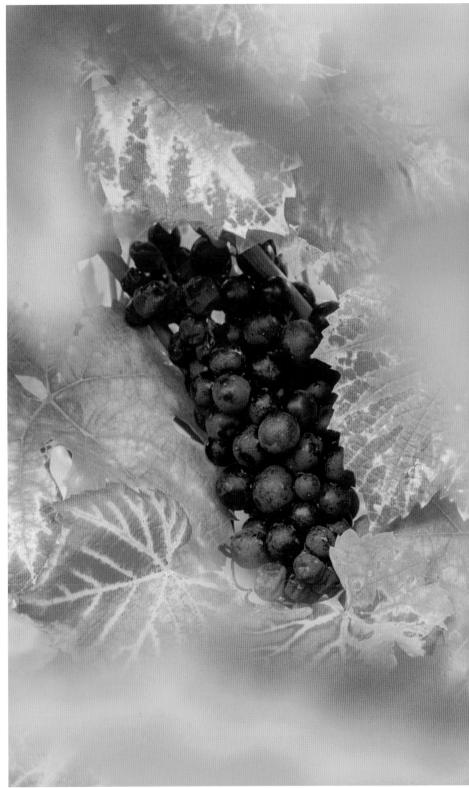

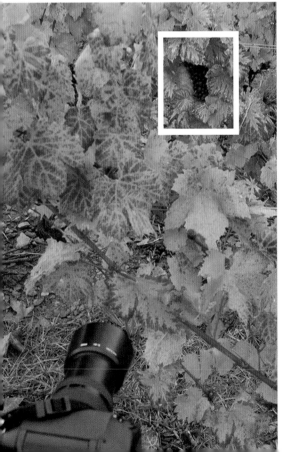

▲ **WHEN PHOTOGRAPHING** this portrait of Diana Sahara, a model I've used often over the past five years when doing workshops in Florida, I chose to frame her through a foreground frame of concrete that was near the edge of a swimming pool. As I focused on her, I made a deliberate choice to shoot at f/5.6 while at 300mm, assuring that the foreground framing would remain out of focus. Interestingly enough, the eye and brain will always assume that if something is out of focus it is *not* important when contrasted with a subject that is in focus. So it's safe to assume that if you wish to bring even greater attention to your focused subject, you might consider "wrapping" it up in out-of-focus tones and shapes.

Nikon D800E, Nikkor 70–300mm lens at 300mm, f/5.6 for 1/800 sec., ISO 100

FOCUS WITH A WIDE OPEN LENS

When shooting wide open with *any* lens, the old adage "What you see is what you get" really is true! In other words, when you are setting the lens to its widest aperture, the only sharpness you can expect to record is that single area of sharpness you are able to see through the viewfinder. If you're focusing on something 5 feet away, you'll record a sharp image of whatever is at 5 feet. Beyond and in front of that point, the "unsharp" area becomes greater. Only if you start stopping the lens down can you expect to record additional sharpness beyond and in front of the point on which you're focusing. (Hint: When choosing to go for that selective-focus look, *don't* use autofocus. Autofocus gets really confused in these kinds of situations. Instead, switch to manual focus.)

▼ **ONE OF** the most valuable exercises I've recommended to my students over the years is to seek out backgrounds or foregrounds that, when rendered out of focus, can be used to call attention to the focused subject.

While on a workshop in New Orleans, my students and I came upon this lone trombone player sitting near a bicycle with a blue plastic box attached to it. I encouraged the students to choose a point of view, combined with the long reach of a 200–300mm focal length, that would include the blue plastic box, rendering it out of focus and in marked contrast to the musician's red, in-focus shirt. As you can see, when the blue plastic box is rendered as an out-of-focus shape it brings some welcome color contrast to the overall composition.

Below: Nikon D800E, Nikkor 70–300mm lens at 300mm, f/5.6 for 1/800 sec., ISO 100

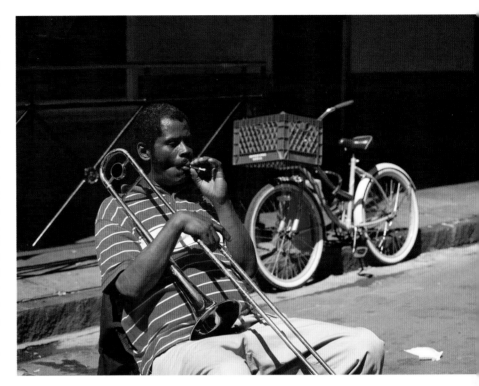

Macro Lenses

The wide-angle lens tells the stories, and the telephoto shows us the details, so what does the macro lens do? It has been my experience that the macro lens does both. When looking at the bright yellow, dew-laden head of a dandelion, a story is not only revealed of how the dandelion has its thirst quenched, but within those same drops (drops that emulate a fish-eye lens), an additional story unfolds of the world that surrounds that dandelion. When turning the macro lens toward an old, rusting, sidelit door at a salvage yard, texture is elevated, revealing countless "exclamation points." And ultimately, the macro lens is able to do this simply because no lens can focus closer, thus revealing those stories that are otherwise hidden from our view.

No lens can expand your vision more than the macro lens, and once you allow yourself to enter this close-up world, it is perhaps more life changing than the world of the wide-angle or telephoto lenses, if only due to the wealth of untapped subject matter. Keep in mind that when it comes to the world of close-up and macro photography, each fraction-of-an-inch shift in your point of view is capable of revealing a completely different compositional arrangement, and with each greater degree of magnification, one-quarter life-size to half life-size to life-size to beyond life-size, you will be entering a completely new and ever-changing world of photographic opportunity. Who knows, you may be one of those photographers who is so taken by the world of close-up photography that you are soon rushing out to buy a 40X power microscope with an adaptor fitted for your brand of camera.

If you are serious about expanding your vision, you must include the world of macro, and you don't have to go far to begin your journey. Whether you choose to buy an actual macro lens or use extensions tubes or purchase the Canon 500D close-up filter, you can easily find subject matter in your bathroom, kitchen, garage, terrace, or yard.

DEPTH OF FIELD IN MACRO PHOTOGRAPHY

As you will quickly learn, depth of field is at a premium in the world of close-up photography. One surefire way to make sure you put yourself at a *disadvantage* is to shoot your subjects angled away from the camera's sensor instead of making certain the sensor is as parallel as possible to the subject. Coming in from an angle, even at small apertures like f/16 or f/22, will render areas that are out of focus in the overall composition simply because the depth of field is considerably shorter in the world of macro. Those out-of-focus areas will be more noticeable the farther they are from whatever your focus point is.

▶ **IN GRASSY** meadows worldwide, an early-morning scene is repeated over and over. As the sun rises to the east, it casts its warm glow into meadows of dew-laden grasses, flowers, and, if you're lucky, spiderwebs. Before entering the meadow, stand at the edge as you face east, get down low, and scan it for these things. You won't have to look far.

Coming upon this family of dewdrops, I was quick to emphasize the height of the grasses. My next challenge was to maintain a point of view that would be as parallel as possible to the subject.

Setting my aperture to f/16, all that remained was to adjust my shutter speed for a correct exposure, and I discovered that with my setting of ISO 200, the correct shutter speed was 1/160 sec. I normally use a tripod for my macro work, as well as the mirror lock-up feature found on my Nikon D800E, but on this particular morning, I relied on a pair of steady elbows to give me the needed stability that so many macro shots require.

Opposite: Nikon D800E, Micro-Nikkor 105mm lens, f/16 for 1/160 sec., ISO 200

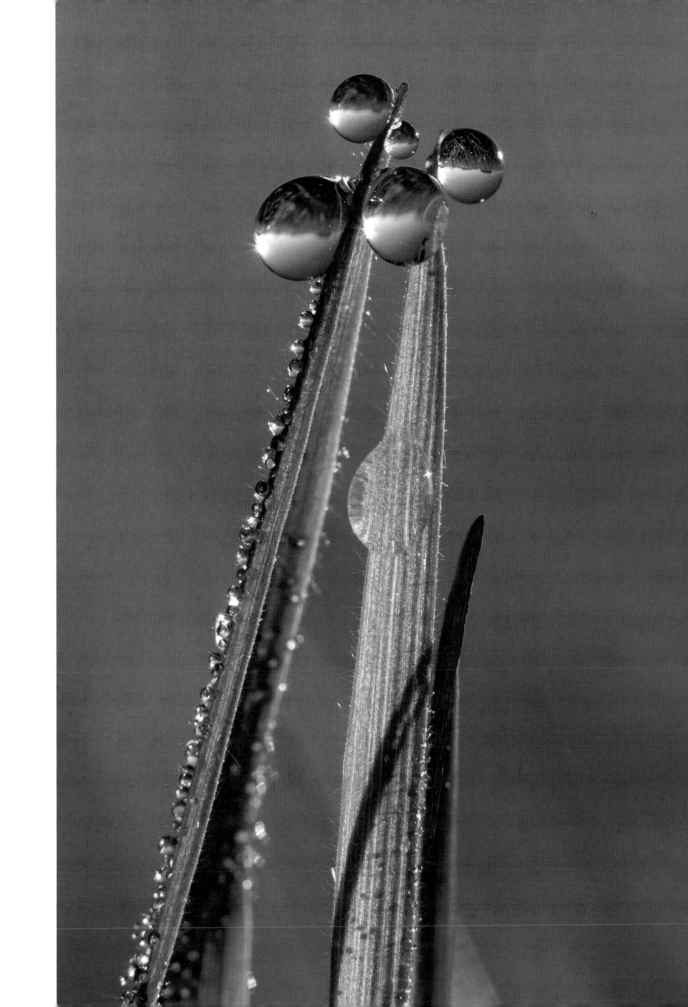

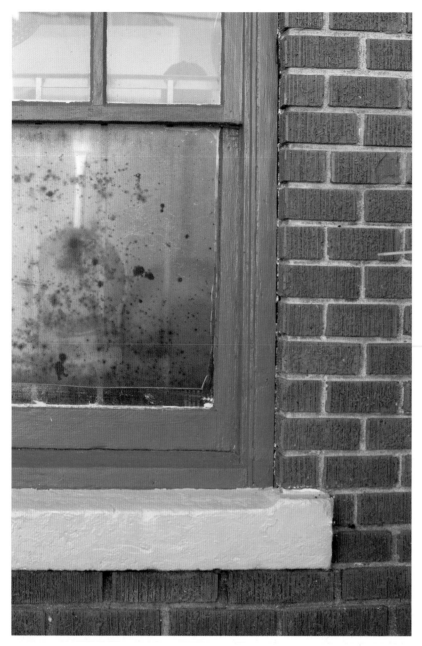

WHILE WALKING the streets of New Orleans, I spotted a brightly painted window along the side of a brick building. On closer inspection, I couldn't help but notice in the window's reflection a silhouette of a "small child," head down, against the backdrop of a blue sky and rainbow . . . yeah, I know, what have I been smoking, right? Honestly, on this day, nothing!

With my Micro-Nikkor 105mm, I was soon filling the frame with that "little boy" and the landscape that surrounded him. I made certain to be parallel to the window, so everything was at the same focal distance.

Right: Nikon D800E, Micro-Nikkor 105mm lens, f/16 for 1/30 sec., ISO 100

MIRROR LOCK-UP

Mirror lock-up is designed to considerably reduce, if not eliminate, the vibration of the mirror that shows up as a blurry effect as soon as you trip the shutter release when using slow shutter speeds such as 1/15 sec. or slower. Check your camera's manual to see if you have the mirror lock-up feature, and if so, get in the habit of using it when shooting at slow shutter speeds. You *will* see a difference!

▶ **AS I** sat on a set of stairs, I glanced up and caught sight of a red metal can. You can see it in the first photograph **(above)**. A few minutes later, I set up in front of this red can, filling up my frame with nothing but the star shape. This particular composition did pose a challenge, because unlike the flat surface of the window in the photo on the previous page, the red can was curved. As a result, I stopped the lens down considerably further than f/16, going all the way to f/40—yikes! You can bet that at f/40 and with an ISO of 100, I was on tripod and using both mirror lock-up and a cable release.

A secondary challenge was overcoming the curiosity of the crowds that quickly gathered around me. They were blocking my light, and as a result, I was forced to use a longer shutter speed than I wanted. But that's why I carry a tripod!

Opposite: Nikon D800E, Micro-Nikkor 105mm lens, f/40 for 1/2 sec., ISO 100

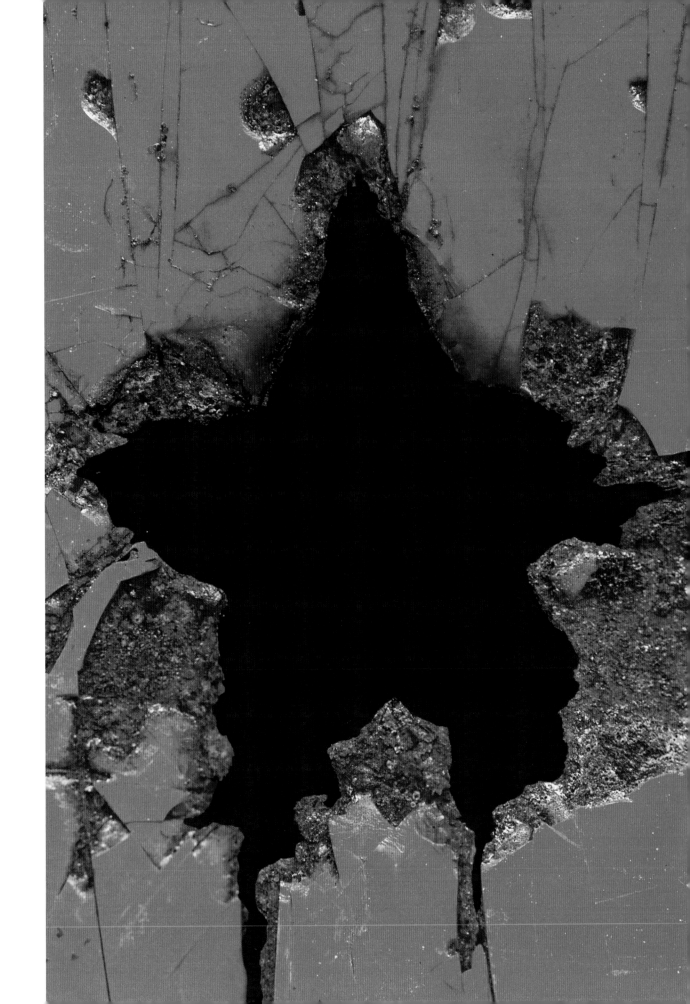

Work the subject!

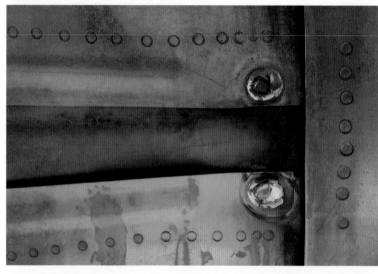

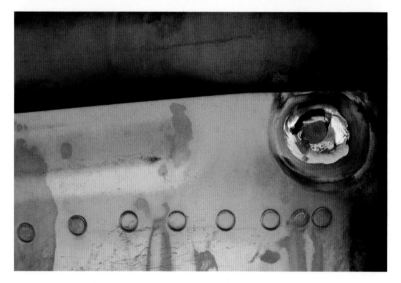

▶ **THIS WAS** my first time ever visiting an air and space museum. Upon entering the one in Pima, Arizona, I made a beeline for the door at the back that took me out into the yard where planes were lined up.

I shot a number of exposures with my trusty 24–85mm, but I'm always on the lookout for those new and unusual macro shots that I can add to my growing collection, and it was about halfway into my self-guided tour that I came upon the compositions you see here.

Note the rivets and welds inside the white box **(left, top)**. With my camera and Micro-Nikkor lens mounted on tripod, I was soon composing two of those welds and rivets and quickly realized that one of those welds was akin to the eye of a turtle, so I was even quicker to move in much closer and began to make the next composition you see here **(left, middle and bottom)**.

I stepped back from the viewfinder, closed my eyes, imagined a frame filled with the "eye," and then returned to the viewfinder to discover that I had not yet filled the frame, so I quickly proceeded to focus the lens in even closer, and the final image you see on the right is indeed the "eye" **(opposite)**!

Opposite: Nikon D800E, Micro-Nikkor 105mm lens, f/29 for 1/25 sec., ISO 200

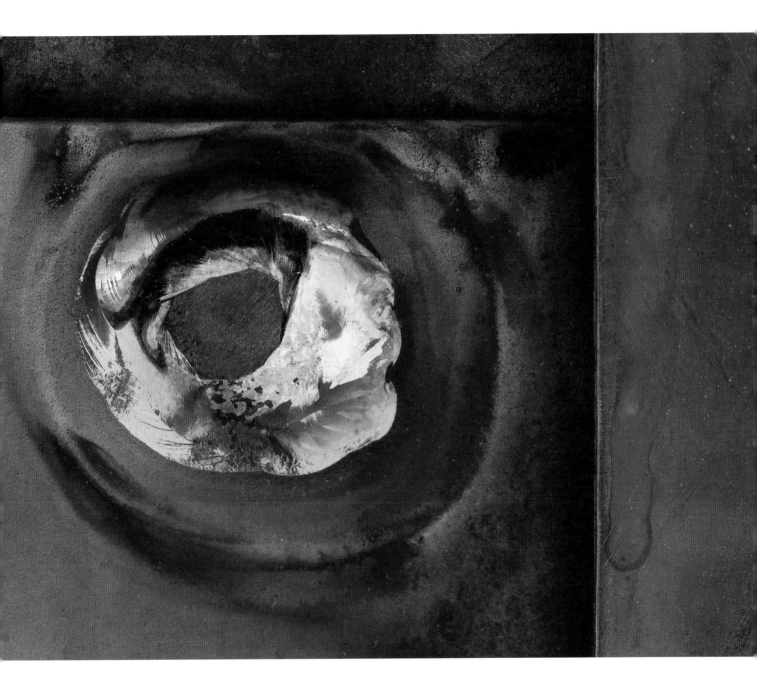

ELEMENTS OF DESIGN

WHAT MAKES FOR A STRIKING IMAGE?

When asked what kind of photographs command the most attention, my answer is always the same: They most often involve commonplace subjects composed in the simplest way. They're successful because they're limited to a single theme or idea—and they're organized without clutter. These powerful compositions are in sharp contrast to many of the pictures taken by amateur photographers today. Amateurs, in their haste to record the image, end up with pictures that often have too many points of interest or in some cases lack a single interest. The resulting lack of direction and subsequent confusion alienates the eye, forcing it to move on, seeking visual satisfaction elsewhere.

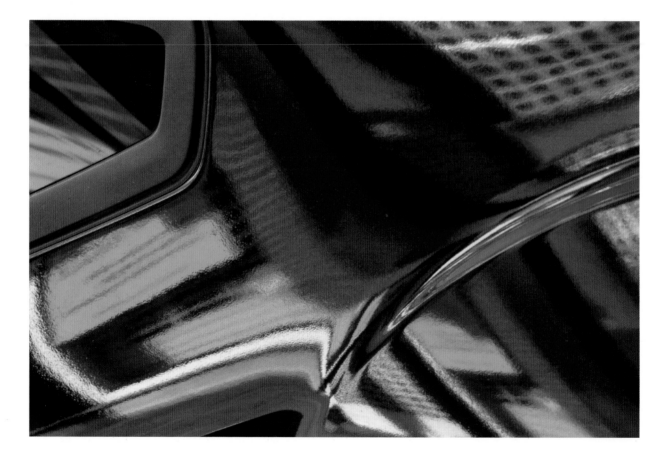

▲ **THANKS TO** a very colorful sign of a bicycle shop directly behind me, the reflection on the curving metal hood of a blue Volvo became much more interesting. Is this image "art"? As with all art, the answer is subjective, but one thing is certain: It's an image with impact—and for good reason. It's an image of shape, line, texture, and color, an image that's made up solely of the elements of design.

Nikon D3X, Nikkor 70–300mm lens at 300mm, f/16 for 1/100 sec., ISO 200

⬡ EXERCISE : Mastering the Basic Principles of Design

Years ago, I began giving students an exercise that I still use today. It can help not only to expand your vision but also to reveal parts of your psyche: your likes and dislikes.

Gather up about eighty of your images, preferably those without people in them. (If you cannot find eighty people-free images, gather up eighty images with people in *all* of them.) Set them aside for a moment, and take a sheet of blank paper and draw six columns on it. At the top of each column, list one of the following: line, shape, form, texture, pattern, and color. Now, begin looking at your pictures, one by one, with a critical eye. Carefully study each one, and make a check mark in the columns that best describe the elements that dominate the composition. It is more than likely that one or possibly two columns will have more check marks than the others. Consciously, we all favor certain design elements. Both the content and the arrangement of your pictures reveal something about your psyche—assuming, of course, that your reason for taking pictures flows from your own feelings and responses to the world around you, and isn't simply an attempt at duplicating someone else's style.

Take notice of which columns have the least check marks. These are your "weaknesses," so grab your camera and head out the door with the goal of creating imagery that addresses these weaknesses. Take only your telephoto or telephoto zoom. Either of these lenses reduces perspective, which enhances good visual design since the factor of depth has been eliminated. As discussed earlier, telephoto lenses also have a narrow angle of view, which lets you focus on the specific visual elements you want to emphasize.

When I wrote the first edition of this book in 1988, my line and pattern columns were heavily checked. Fast-forward to the year 2014, and I have an equal amount of check marks under all of the columns! Mastering the basic principles of design is a liberating experience. These principles will allow you to chart your course and set sail on an ocean of ideas.

Imagine finding yourself lost out on the open road. You finally see a lone gas station up ahead, and you ask the attendant for directions. He begins to offer plan A and plan B and plan C, each with very specific details. Rather than having found the clear, simple, and concise directions you were seeking, your brain is now swimming in a sea of confusion. Clear and concise directions are all that you want. And that's what most of us want. We want to know the plan, the schedules, the dates, the time. Without order, chaos will soon be upon you.

Successful photographs rely on order, too. And the elements that bring order to photographic composition are line, shape, form, texture, pattern, and color—these are the *elements of design*. Every photograph, successful or not, contains at least one if not several of these elements, regardless of the subject. All of these elements have tremendous symbolic value—particularly line, texture, and color. They can be experienced as either hard or soft, friendly or hostile, strong or weak, aggressive or passive. Most of the time, we see and utilize these elements with unconscious abandon. Your memory and your life experiences affect your sensitivity to various visual components, and this in turn affects how you use them in your compositions.

LINE

Of the six elements of design—line, shape, form, texture, pattern, and color—which is the strongest? Line! Without line there can be no shape, without shape there can be no form, without shape and form there can be no texture. And without line or shape, there can be no pattern.

A line can be long or short, thick or thin. It can lead you away or move you forward. It can be felt as restful, rigid, active, soothing, or threatening. The emotional meanings of line cannot be overlooked. Some of us experience a thin line as sickly or unstable, and yet others see it as sexy, cute, and vulnerable. A thick line for some may feel stable and reliable, but for others unhealthy and stern.

In nature, curvilinear lines dominate. They are the wind, the rivers, the surf, the dunes, the hills. Curvilinear lines are experienced by most as soft, gentle, restful, and relaxing. Jagged lines are also present in nature, the most obvious being mountain ranges and their peaks. They have also shaped much of history, as wars were fought with arrows, knives, spears, and swords. Jagged lines can be experienced as sharp, dangerous, forceful, chaotic, and threatening. Even the investor on Wall Street is all too familiar with the chaos caused by the jagged line.

The diagonal line evokes feelings of movement, activity, and speed. It is solid; it is decisive. The cyclist knows the diagonal line presents a challenge going up and the exhilaration of speed going down. The diagonal line will always breathe life into an otherwise static composition. Being conscious of the

subtle feelings associated with lines will allow you to manipulate a photograph's emotional impact.

Every photograph is a combination of the elements of design. The challenge that we all face is deciding which of these elements to include or exclude in order to arrive at the most compelling composition. It is, after all, the elements of design that direct the eye through the composition. This can be done with leading lines or an obvious pattern or the eye's interpretation of a given texture, causing the brain to react with either trepidation or tranquility.

▼ **ONE OF** the greatest keys to using line is to use it as a way of leading the viewer into those areas of the frame that are of the utmost importance. Sometimes that line *is* the subject, while at other times, the line plays a much subtler role, somewhat "hidden" from the viewer yet clearly responsible for leading the viewer throughout the scene. These two images both rely on the use of a leading line, yet the image **(opposite)** of the fallen tree is much quicker to take the viewer from the bottom of the frame to the top. The reason for this is quite simple: the line itself is very rigid and direct. In the other example **(below)**, the leading line is the much more carefree, loose, and meandering. Yes, lines can dictate to the viewer their level of importance by their thickness (thick lines of course have greater visual weight than thin ones), but the direction of the line also plays a vital role in creating a sense of urgency or a more laissez-faire attitude.

Opposite: Nikon D300S, Nikkor 12–24mm lens at 16mm, f/16 for 1/50 sec., ISO 100, Lee 3-stop graduated ND filter

Below: Nikon D3S, 24–85mm lens at 30mm, f/11 for 4 seconds, ISO 100

▲ **IN HONG KONG**, there are several bird markets where birds are for sale and where the owners of caged birds come and hang their birds in the hopes of getting their pets to sing more often.

At this particular market, the pet shop owner had just placed a large cage of lovebirds on display in full sun, and I noticed that four or five of them seemed to be far more content huddled together than spread out on the many perches within the cage. I grabbed my 70–300mm lens and a 12mm extension tube and was soon immersed in composing frame-filling lovebird compositions. The strong diagonal lines that result from their huddled bodies leave no doubt that they're on the move. Such is the emotional message of the diagonal line.

Nikon D800E, Micro-Nikkor 70–300 mm lens with 12mm extension tube, f/11 for 1/160 sec., ISO 200

▼ **NOTICE THE** very different message that these two nature compositions offer up. Note the "carefree" curvilinear line or shape of the butterfly itself **(left)**, and add to that the curvilinear, meandering line (the grass blade) that appears to be serving up the butterfly for our viewing pleasure. It feels playful.

Now, compare this composition to that of the dragonfly **(below)** attached to the grass blade. Note the two strong diagonal lines, which are anything but meandering. There is an all-business feeling to this image. Nothing playful about it at all! It isn't the subject that's sending this message to our eye and brain, but simply the lines and their corresponding emotional messages.

Left: Nikon D300S, Micro-Nikkor 105mm lens, f/11 for 1/200 sec., ISO 100

Below: Nikon D300S, 300mm lens with extension tube, f/5.6 for 1/250 sec., Nikon SB-900 flash

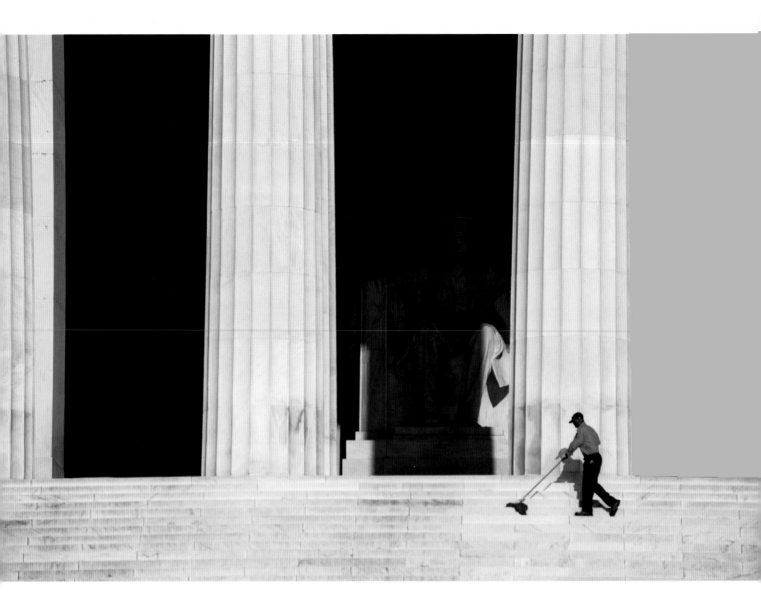

▲ **THERE ARE** several elements of design at work in this very strong composition, not the least of which is the strength exuded by the very wide lines of the pillars at the Lincoln Memorial in Washington, D.C. Lines can be thick, lines can be thin, and it's clear in this case that the much thicker lines of the Lincoln Memorial are in very sharp contrast to the incredibly thin line of the mop handle in the hands of the man mopping the stairs. Of course we must also consider the human form; nothing else comes close to duplicating its shape, and as a result, we are quick to recognize the tremendous size of the Lincoln Memorial.

Nikon D800E, Nikkor 70–300mm lens at 300mm, f/16 for 1/125 sec., ISO 100

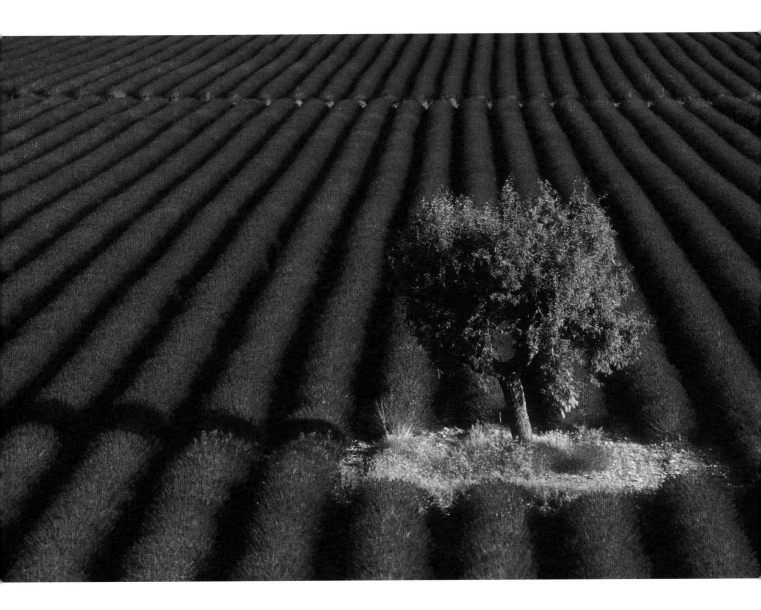

▲ **I'M A** fan of "aerial" photography—in particular, shooting aerials in agricultural areas—and since I believe a great deal in the power of line, there is no better opportunity to get compositions of line within these agricultural areas than from above. But just how, exactly, other than renting a pilot and helicopter can we get high above these many lines that await?

I don't like drones and the fast shutter speeds required to shoot from them. Instead, I use the same method for aerials I've been using for years: rent a bucket truck with a 90-foot hydraulic lift! (This is the same kind of truck used by utility crews around the world.)

From the ground, I couldn't avoid seeing the distant mountain range and other trees in the background in this landscape of lavender fields atop the Valensole Plain in Provence, France; but from above, this "lone" tree really does appear to be all alone in these vast fields of converging lines of lavender!

Nikon F-5, Nikkor 35–70mm lens at 35mm, f/11 for 1/250 sec., Kodak V100S slide film

SHAPE

Shape is more fundamental than form, texture, or pattern, because shape is the principal element of identification. You may think you smell a fragrant rose, but until you see its shape, you can't make a positive identification. You may hear a sexy voice on the radio, but unless you actually see the speaker, who knows if he or she has that sexy shape?

From prehistoric through modern times, man's need and ability to identify objects by shape has endured. This ability—or lack thereof—provides, alternately, security and anxiety. If the caveman couldn't readily identify the shape of that herd on the horizon, he very well might have walked right into a family of saber-toothed tigers. During World War II, if soldiers from different countries hadn't had different helmets, they might have ended up shooting at their own comrades. As the shape of the car comes over the crest on the horizon, you can now relax knowing that, although she arrived later than planned, your daughter has returned home safely from college. Horror movies play off our anxiety about the shape of the unseen, and most have a standard script that leaves the monster off-screen for better effect. No one actually sees the creature, leaving the imagination to run wild. The audience wants this "thing" identified, because seeing its shape would finally reduce, if not eliminate, everyone's anxiety.

When composing a photograph that depends primarily on shape, there are several things to remember. First, shape is best defined when the subject is frontlit or backlit. Second, there should be a strong contrast between the shape and its surroundings. If you want to shoot silhouettes, there are no better times than just before sunset and several minutes following, as well as several minutes before sunrise and several minutes after. Form and texture both vanish at these times, leaving only stark outlines and profiles against the sky. The silhouette is the purest of all shapes, so it's not surprising that silhouettes continue to be the most popular shapes to shoot.

Since both are seen as two-dimensional, shadows and silhouettes are perhaps the subjects that most define shape. For example, it should be clear to most everyone that the shadow in the image (**opposite**) is in fact a chair, defined as such by its shape. In much the same way, we are quick to identify a person's silhouette jumping in front of an illuminated sign of the U.S. flag simply because we recognize the shape and just as easily identify a tree from its lengthy shadow falling across a field of tulips and nearby grazing field for cows. See the next page for examples.

◀ **IN THE** small town of Schermerhorn, Holland, I stopped for a late-afternoon coffee break, and if not for the low-angled sun, the long shadow of a chair would certainly not have been casting itself across the paving stones and nearby wall. Silhouetted shapes are often associated with strong backlight, as when objects are photographed against a setting or rising sun; yet one mustn't overlook the opportunities to shoot shadows, which means turning our attention in the opposite direction. Once you have determined that you do, in fact, wish to emphasize shapes, it's imperative that you set your exposure for the much brighter light surrounding your subject. In this instance, setting my exposure for the bright wall made perfect sense, as this would greatly under-expose the darker shadow, thus turning it almost black. A black shape or a black silhouette is, in my view, the ultimate aim with shape.

Nikon D800E, Nikkor 24–85mm lens at 35mm, f/16 for 1/160 sec., ISO 200

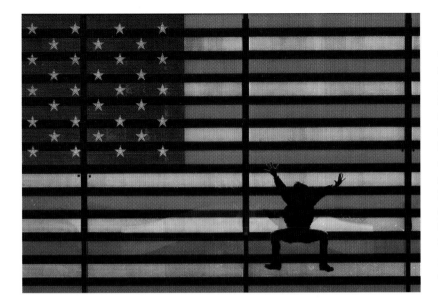

◀ **IN NEW YORK CITY'S** Times Square, a U.S. Army recruiting station makes its presence known with one exterior wall that showcases an illuminated flag. One of my students was able to climb up a small railing in front of this wall and use it as a launchpad to jump high into the air **(left)**. As my subject leapt, my exposure was for the much brighter ambient light of the flag and *not* for the much darker ambient light that was falling on my subject. As a result, the figure recorded as a silhouetted shape.

Left: Nikon D800E, Nikkor 70–300mm lens at 120mm, f/8 for 1/400 sec., ISO 200

▼ **IT'S NOT** uncommon to see a number of "sky bridges" in Dubai, linking buildings together **(below)**. At this particular location, I was able to combine a number of other shapes and forms in the background with the well-defined shape of this glass-enclosed sky bridge in the foreground. With my exposure set for the brighter light outside, I was assured of recording silhouetted shapes in the sky bridge, and all that remained was to wait for someone to come walking through. I was fortunate to get a young woman moving through the walkway clad in the familiar dark burka. Her shape is unmistakably human and is center stage, since nothing else in this composition remotely resembles her.

Below: Nikon D800E, Nikkor 70–300mm lens, f/11 for 1/200 sec., ISO 200

▶ **THERE SHOULD** be no doubt that you are seeing the shape of a tree falling across this field of tulips **(right)**, and in addition to functioning as a leading line, this tree also calls attention to an additional shape: the cow at the top of the frame.

It's an easy composition to make *if* you are willing to get a bit off the ground. (I climbed atop the roof of my van and stood where the roof meets the driver's-side door.) From ground level this composition would not have been possible.

Right: Nikon D800E, Nikkor 24–85mm lens at 50mm, f/16 for 1/125 sec., ISO 200

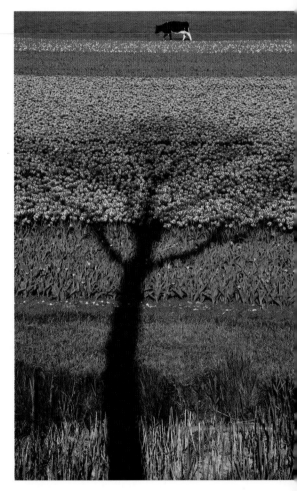

▼ **WHEN YOU** have been shooting for as long as I have, it can be a daunting task to come away with something fresh. The iconic Public Market sign in downtown Seattle is one such subject. This was my fourteenth time standing in front of that sign and I was confident that I had shot it in every way possible.

But on this particular day, I saw for the first time the graphic possibilities of making a frame-filling image of the word "to" by simply zooming in so close that only the letter T and the round clock would fill the composition. I knew the red letters and white-faced clock would contrast nicely against the clear blue sky.

Shape doesn't always mean a silhouette. Granted, one could make the argument that this image, due to the subtle sidelight, is more about form than shape, but I disagree!

Bottom: Nikon D800E, Nikkor 70–300mm lens at 240mm, f/16 for 1/200 sec., ISO 200

FORM

Basically, form is seen in three dimensions, while shape has only two. Form assures us that an object has depth. Since communicating form depends on light and the resulting shadows, it's best to photograph a subject under sunny skies and sidelight to reveal its form. The contrast between the light and dark areas of a sidelit shape give it form.

Squares, rectangles, triangles, and circles evoke different emotional responses. When the forms of these shapes are revealed (usually with sidelight, see page 121), their messages are amplified. A backlit circular shape represents wholeness, yet when photographed sidelit, the form is revealed, and the curvilinear shapes that result take on sensual meanings, reminding us of the human form. The three-dimensional forms of rectangles, squares, and triangles suggest the man-made world.

Sidelight plays an important role in defining form. Why is this? Because only with sidelight can

◄ **SHAPE IS** two-dimensional, form is three-dimensional, and you can see that 3-D effect **(opposite)** in this early morning, sidelit view of the Sheikh Zayed Grand Mosque in Abu Dhabi. Look no further than the top third of this composition and you will see the subtle changes in light and shadows that in turn reveal the volume and depth of the mosque. Again, it is sidelighting that's responsible for form—it's really that simple. If your compositions lack volume and depth, consider shooting your subjects when the sun (or other light) is coming in from the side!

Opposite: Nikon D3X, Nikkor 70–300mm lens at 247mm, f/22 for 1/50 sec., ISO 200

one expect to find both light and shadow, and it is the combination of shifts in light, dark to bright, that is responsible for bringing out a subject's form. Rarely does overcast light bring out form, and form is never revealed fully when a subject is frontlit and not at all when backlit.

And what may be surprising to some is that in addition to sidelight coming from the left or right, it can, in fact, come from the top, as in the direct overhead light of midday! Are you shocked to hear this kind of news? If you're familiar with my other books, you know I'm fond of saying that the only thing midday light is good for is working on your tan, but I'm also here to say that if you find yourself poolside, as I was on the day I made the image **(above, right)**, opportunities to shoot overhead "sidelight" are present even at high noon.

▲ **SAY HELLO** to Mylinn, one of three models I worked with in Orlando, Florida, at the home of the former Chicago Bulls basketball player Horace Grant. At the end of a large and long swimming pool, Mylinn stood below the head of a large, blue sculpture, and you will surely notice the "sidelight" coming from the sun directly overhead; evidence of this is seen in the subtle shadows around the eyes, nose, and lips of the sculpture and in the shadows under Mylinn's lips and neck. To avoid the raccoon-eye effect you would see in directly overhead, midday light, I used a large gold reflector, placed just out of view, resting directly on top of the pool water just below Mylinn's face.

The one thing that's clear, and is a point not to be lost, is that midday light, which is actually overhead sidelight here, is responsible for showcasing the form in this composition.

Above: Nikon D800E, Nikkor 70–300mm lens at 220mm, f/6.3 for 1/800 sec., ISO 100

▲ **FOR MANY** people throughout the United States, the winter of 2013/14 was extremely long, very cold, and thus memorable, unfortunately. Those of us who lived in Chicago were caught in winter's grasp all the way through April.

I knew that the previous evening's snowfall would be short-lived due to the promised forecast high of 39 degrees Fahrenheit, so I was in a hurry to reach downtown Chicago within an hour or two of sunrise. Fortunately, I timed it perfectly, as a portion of Chicago's famous *Cloud Gate* sculpture, or what Chicagoans call The Bean, was still covered in patches of snow—snow that when composed up close, and in combination with some of the city building reflections, created the illusion of white puffy clouds **(above)**. And since these "clouds" are sidelit snow patches, a great deal of form is revealed.

Above: Nikon D800E, Nikkor 24–85mm lens at 32mm, f/22 for 1/30 sec., ISO 100

▼ **IT WAS** at the Pima Air & Space Museum in Arizona that I made one of my most favorite compositions of form **(below)**. The abstract nature of this particular composition is obvious; it is nothing more than a reflection. Yet it is the form, the shape, and the colors visible in this reflection that make the eye stop and stay for awhile to study the photograph.

To me, this image looks like an airplane in the sky, flying low in the desert and casting its shadow upon the sand. Yet as you can see in the larger view **(right)**, just to the left of the head of one of my students is the reflection that I shot. Clearly this isn't a plane flying over the desert but merely an illusion due to a reflection that's sidelit by the overhead midday light.

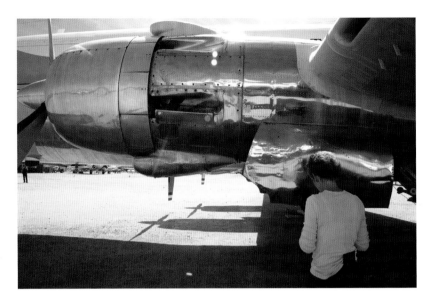

Below: Nikon D800E, Nikkor 70–300mm lens at 240mm, f/16 for 1/80 sec., ISO 100

TEXTURE

Perhaps no element of design is more capable of exuding deep emotion than texture. Even if you only witness someone being thrown from a bicycle, a chill still goes down your spine as you see the person skidding, hands and face down, across a gravel pathway. In our daily language, we use texture to describe most everything. A rough day, a soft touch, a sharp mind, a dull movie, a sticky mess. A woman's soft voice may arouse delicate or vulnerable feelings, but a man's gravelly voice may elicit fear or feelings of aggression. A hard-nosed boss seldom wins the affection of employees, whereas a smooth-talking boss often does. These are just a few examples of texture's influence.

Although we use texture as a means of describing events in our lives, it's not as readily apparent in photographic work. Texture, unlike line or shape, doesn't shout to make itself known. Of all of the elements of design, it is the one element that is most often "hidden."

The challenge in seeing, as well as conveying, texture depends on one critical element: lighting. A compelling image of texture—unlike line, shape, pattern, or color—is dependent on low-angled sidelight. So, it's imperative that you search for texture on sunny days in the early-morning or late-afternoon hours. Although some texture-filled subjects are obvious, like sidelit tree bark, others require much closer inspection, and you may find your macro lens getting lots of use.

Once you begin to see—and compose with— texture, you may discover its other use in creating compelling landscape imagery: as a foreground element in a vast compositional landscape, texture can arouse a heightened emotional response from viewers as their sense of touch is ignited.

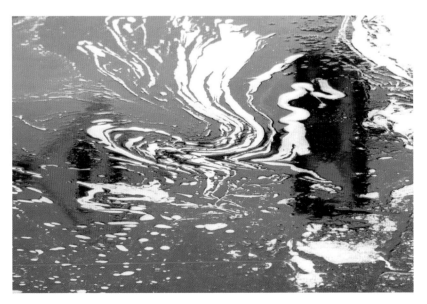

◀ **AS A** guy who grew up in the Pacific Northwest, you can imagine how much rainfall I've seen. So I was surprised to hear that this particular morning in Tucson marked the area's first day of measurable rainfall in six months. The only place I have ever envisioned rainfall but once every six months was heaven!

Standing at this street corner near the Barrio neighborhood, I was enthralled by both the textures and colors unfolding before me, as the sloping street pushed the water toward the curb and the traffic light went through its series of changing colors. There's a lot going on in these three images, beginning with the overall wet and foamy texture along with curvilinear lines, various shapes, and colors.

All Photos: Nikon D800E, Nikkor 70–300mm lens at 300mm, f/22 for 1/80 sec., ISO 320

Cityscape

▶ **I WAS** in Chicago when my students and I stopped near the radio station WGN on Michigan Avenue and I asked, "Where is the shot here?" Not surprisingly, no one had a clue. I don't say that to be flippant but rather to make another point about learning to see.

When you start poking the camera at subjects that would not normally get your attention, you will begin to pick up a number of new ideas—and your ability to see becomes stronger.

When I called attention to the reflection of several buildings and flags in the granite planter boxes, there was an "aha" moment, and soon the students were making quick work of this heavily textured "cityscape." With shots like this, you won't have to rely on the texture plug-ins on your computer.

Right: Nikon D800E, Micro-Nikkor 24–85mm lens at 24mm, f/16 for 1/50 sec., ISO 200

▼ **I STOPPED** in at a local tire store while conducting a workshop in Las Vegas, explaining to the students that this could be a great place to get some portraits.

While there I came upon a really terrific opportunity to convey the texture and color of a simple cupboard door at the tire store. I focused in on an area outlined in black in the image **(top left)**. I reached for my macro lens, mounted it and my camera on my tripod, and did nothing more than move in extremely close so that I would be able to create a composition that included the scarring of a spot where once there was a hinge and also a touch of orange that existed between the two doors. Although I shot this composition as a horizontal, I also share the vertical version. (As I tell my students, a technique that can certainly improve your ability to see is to be aware, particularly when shooting abstracts, that rotating or flipping the image after you shoot it can sometimes render an even greater composition.)

Left and below: Nikon D800E, Micro-Nikkor 105mm lens, f/16 for 1/15 sec., ISO 100

PATTERN

Six months after my introduction to photography, I found myself experiencing a level of enthusiasm that seemed to have no limits. On one particular day, I was focusing my camera and lens on the bright red tomato and deep green cucumber slices that I had just prepared as part of my lunch during a camping trip. The combination of the colors, the texture, and most of all the pattern caused me to shoot more than several rolls of film.

I later realized that this "discovery" not only led me to more and more pattern-filled opportunities but also revealed some of my psychology. All the elements of design elicit some very profound emotional responses, and for me, pattern had this uncanny ability to evoke emotions of stability, consistency, and belonging. It felt safe, secure, and reliable because it was predictable. Whether on the job or at home, all of us have some degree of predictability. This predictability is expressed as patterns of behavior. A burglar looks at pattern as a means to successfully steal from you while you're away at work; the detective looks for patterns as a means to capture the burglar. A psychologist looks for patterns as a way of helping us understand our behavior, while a parent becomes accustomed to the pattern of the newborn. Without pattern, our world would be pure chaos.

How difficult can it really be to make dramatic compositions of pattern? Well, if the work done by beginning students in my Art of Seeing class is any indication, the answer is quite difficult, and I can fully appreciate why that is. We are told by many within the art community that pattern is everywhere, yet compelling compositions of pattern are few and far between, and it has much to do with the lack of attention paid, at least photographically speaking, to what is going on in the corners of the photographic frame. More often than not, compositions of what we're told are pattern *only* are, in fact, compositions that display pattern that is oftentimes interrupted by objects or subjects that have nothing to do with the overall pattern that has been captured.

Simple patterns are readily visible to even the layperson, such as a stack of two-by-fours at The Home Depot or the pattern of the yellow chrysanthemum blooms in that large pot in the garden center, but even here the first rule of composing even the simplest of patterns applies: fill the frame, edge to edge, top to bottom, side to side with just the pattern. Empty corners will "scream" at the viewer every time. Yes, you want your pattern picture to be "loud," but there is a distinct difference between a loud yet soothing voice and that of a screaming voice.

▲ **GETTING INTO** the habit of looking up as well as down will increase your ability to see. In this case, by simply looking up outside the entrance to Planet Hollywood in Las Vegas, I found an obvious opportunity for capturing pattern in these hanging chrome "planets." As you look at my first example **(opposite, bottom)**, you see that I incorporated not only the hanging planets but also some very bold lines of color. But these lines of color *do* distract the eye from the pattern, and the only solution was to change my point of view, since in this composition I wanted everything to be singing the same tune. As you can see **(above)**, I did find a different point of view, and this uninterrupted repetition does in fact increase the overall *volume* of the planets.

Both "composed" images: Nikon D800E, Nikkor 24–85mm lens, *f*/16 for 1/50 sec., ISO 320

▼ **IT WAS** at a restaurant bar in Hoorn, Holland, where the opportunity to photograph a simple pattern of upside-down wineglasses presented itself. I didn't have my camera or lenses at the time, but that didn't mean I quit "seeing." In fact, most of the time, I am in a constant photographic frame of mind. Knowing I would be having breakfast at this location for the next three days, I returned the next morning with my gear and made the photograph you see here, with the blessing of the restaurant owner. I think in my last hundred requests to make photographs of this type, I have been turned down a total of zero times!

Below: Nikon D800E, Nikkor 70–300mm lens at 300mm, f/11 for 1/60 sec., ISO 200

▼ **IF YOU** aren't careful, you will zip right past pattern compositions. Instead of only trying to figure out a point of view that separates a single flower from the bunch, consider also shooting the pattern that many of these same flowers make.

I came upon these bright red roses at the local flower market in Lyon, France. I purchased several bunches of them, and, remaining under the overcast sky, began making the two compositions you see here. It's obvious where I'm placing the emphasis in both: In the first one **(right)**, it's on the passion and sensuality of the red rose (indicated by the frame-filling power of the lines and the color red). And in the second **(below)**, it's on show-casing the roses together because the size of the lines has been reduced due to my pulling back from a single rose to include many more.

Both images: Nikon D300S, Nikkor 24–85mm lens with macro capability, f/16 for 1/40 sec., ISO 200

▼ **WHERE IS** the pattern here? Yes, it's in the tires, and when I place my subject against the pattern I'm able to render a composition where my "lead singer" is supported by "background vocalists."

The Chandni Chowk neighborhood of New Delhi, where I made this image, remains one of my top ten places in the world to photograph people, and that has much to do with the unlimited choices in patterned backgrounds.

Note the random pattern of tires and rims surrounding him; since he is *nothing* like the shapes around him, he is the "lead" against a background of humming harmony.

Below: Nikon D800E, Nikkor 24–85mm lens at 65mm, f/5.6 for 1/320 sec., ISO 100

◀ **THIS COLORFUL** tower sculpture by Raymond Moretti is located in La Défense in Paris and is called *Cheminée d'Aération*. Built in 1990, it is nearly one hundred feet high and composed of concrete and fiberglass—some 700 narrow, colorful fiberglass tubes form a circle around the concrete tower.

It was during a Paris workshop that one of my students agreed to have a "portrait" taken against the backdrop of this sculpture. I am quite fond of this composition, as it calls attention to the idea that pattern can be used to *scream* about a subject's importance. If I hadn't included the figure, this image would not have *nearly* the impact, but with the figure, it's as if the pattern is screaming, "Hey, she is *not* part of us!" And because she is *not* part of the pattern, she becomes the true focus.

Both photos: Nikon D800E, Nikkor 24–85mm lens, f/8 for 1/250 sec., ISO 100

COLOR

Some time ago, I was sitting in a local café in Lyon, France, reading the day's news in the *International Herald Tribune*. Several minutes following my arrival, two young men walked in and took a seat within earshot of me. What caught my attention was one young man's overstuffed camera bag and the two Nikon F100 cameras hanging from his neck. He was either a very serious amateur or a seasoned professional. Over the course of the next thirty minutes, their discussion centered around photography, and of all that they said, one comment made by the man with the gear stood out the most: "Color is so obvious. Where is the surprise in that? The real art in image-making lies in shooting black and white."

This is neither the time nor the place to begin a debate on what constitutes art in photography, whether in color or black and white; however, this *is* the perfect opportunity to address the fact that color is indeed obvious. It is *so* obvious, in fact, that many photographers don't see it at all! If people really saw color, they would be far too consumed by the need to shoot color *if only* for color's sake.

To really see, and become an effective photographer of color, there's much to learn. Color has many, many messages and meanings. You must become aware of color's visual weight and the subsequent impact it has on line and shape, as well as its varied hues and tones.

Although the subject of color is deserving of its own book, if not a whole set of encyclopedias, I will limit my discussion to the primary (red, blue, and yellow) and secondary (orange, green, and violet) colors. Primary colors are called such because they cannot be created by mixing any other colors. The mixing of any two primary colors results in a secondary color: Mixing red with blue makes violet, mixing red with yellow makes orange, and mixing blue with yellow makes green. Color is often discussed in terms of temperature, with reds, yellows, and oranges (associated with the sun) often described as warm colors, and blues, violets, and greens (associated with water and shadows) often described as cool colors.

Red is known as a passionate and powerful color. It is the color of love and the "power tie" in the white-collar world. It is stimulating, exciting, and motivating. It is control, rage, and power. It is the color of blood, stop signs, and taillights. It is also the color that advances the most of all colors. What this means is, if you were to place red, orange, yellow, green, blue, and violet signs in a field all at equal distances from you, the red sign would appear closer than the others.

Of all the colors often placed with red, blue is one of the most popular, in large part due to blue being one of the colors that recedes the most. Blue is the infinite sky. It is a cool color, able to calm and nurture. It's refreshing, soft, safe, and dependable. It is sensitive and peaceful. Blue sheets "feel" cooler on a hot summer day than do tan, apricot, or lemon-yellow sheets.

Yellow, on the other hand, is light. It is playful, creative, and warm. It can also represent cowardliness and illness. It is, like red, a color that advances.

Orange has the distinction of being the only color that shares its name with a fruit, and because of this, the color orange is associated with fruitfulness. It is fire and flames; it is warmth; it is the sun; it is lust, health, vigor, excitement, and adventure. Orange results from the blending of red and yellow; a perfect fifty/fifty blending results in a "perfect" orange. Orange, like red and yellow, is also a color that advances.

Green, the most dominant color in nature, is a symbol of hope and recovery, and of freshness and renewal. Think of the many green buds of the trees following the harshness of winter. It's a symbol of fertility, as exemplified by the many brides who wore green during the Elizabethan era. It represents growth as well as abundance. It's also the color of aliens, envy, seasickness, and phlegm. Green results from the blending of yellow and blue. Like blue, it recedes.

Violet, or purple, is symbolic of royalty and Christianity (think of the purple robes of kings, queens, and priests). It commands respect, signifies wealth, implies leadership, and connotes spirituality. The origin of purple as a dye goes back to ancient Greek times when a species of mollusk was found to yield—through an elaborate and expensive process—a dye subsequently called Tyrian purple, which was so expensive only the wealthiest could afford it. A blending of red and blue, violet is also a recessive color, even more so than blue and green.

So, where does one begin to look for color? Many outdoor photography enthusiasts will head for the mountains, deserts, beaches, or flower meadows, while a few others start their search on city streets, in alleyways, and even in auto wrecking yards. Regardless of where your search takes you, make it your goal to shoot compositions that first and foremost say *color*, as opposed to landscape, flower, portrait, or building. I often suggest to my students that wherever they choose to search for color, they begin to do so with the aid of a tele-macro lens. I'm a big fan of the Nikkor 70–180mm micro lens, but any tele-macro lens (or moderate telephoto with a macro feature or telephoto used with extension tubes) will do the trick.

It has been my experience that narrowing your search to the much smaller "macro" world will, in fact, result in a much higher success rate. Almost without fail, many of my students who do this soon discover that they're seeing color possibilities not just with their close-up equipment, but also with their long telephotos and their wide-angle zoom lenses. One student's remark following several days of shooting color with her macro lens probably best sums up the feelings of most: "I feel like Lazarus. The discovery of color has awakened me!"

As I said earlier, color is so obvious, and just like the air we breathe, it's everywhere. A path toward creative image-making benefits from a much higher awareness of the color that surrounds you.

Two Sets of Primary Colors

The primary colors that I refer to—red, blue, and yellow—are known as *subtractive* primary colors. From them we get the subtractive secondary colors—violet, orange, and green. The subtractive color system involves colorants and reflected light. It uses pigments applied to a surface to subtract portions of the white light illuminating that surface, and in this way produces colors. Combining the subtractive primary colors in equal parts produces the appearance of black. Color painting, color photography, and all color printing processes use subtractive color.

However, there is also another set of primaries called *additive* primary colors, which are red, green,

and blue. From these we get additive secondary colors—cyan, magenta, and yellow. Additive color involves light emitted from a source before it is reflected by an object; it starts with darkness and adds red, green, and blue light together to produce other colors. When combined in equal parts, the additive primary colors produce the appearance of white. Television screens, computer moniters, digital and video cameras, and flatbed and drum scanners all use the additive color system.

Again, it's the *subtractive* colors that I'm talking about here. They have been used by artists for centuries, and they are the ones you should keep in mind when working with color.

The color wheel is an ordered arrangement of twelve subtractive colors that helps to show their relationships to one another. For example, pairs of colors that fall opposite each other on the wheel are called complementary colors; when placed side by side, these pairs complement and intensify each other. Also, each primary color falls opposite a secondary color, and each secondary color falls somewhere between the two primary colors from which it is made. The relationships go on and on. Studying the color wheel can help you get a better feel for colors and how they affect one another.

What we know and what has been taught about color has its basis in nature. A simple observation of color in nature quickly reveals the multitude of harmonious "blends" that Mother Nature serves up, and with subtle shifts in our point of view, we can boost or lessen a color's vibrancy. For example, when shooting a bright red autumn leaf against a clear blue sky, the red of that leaf is far more pronounced, more brilliant, and its advancing nature is intensified against the recessive blue sky—and as such even more depth and brilliance is achieved. Contrast this scenario against a point of view that finds me

◈ EXERCISE : Composing with Color

The "right" colors create a balanced harmony, and one of the excercises I have my students do is not only simple but also very revealing. Just make sure to do the photographic setup I describe out on your deck or in your yard twice, once on a sunny day and once on a cloudy day.

Pick up some colored construction paper at the arts and crafts store, then stop off at the grocery store and pick up some colorful fruits and veggies—tomatoes, lemons, limes, red cabbage, green apples, carrots, various peppers, blueberries, grapes, and the like.

One by one, place these fruits atop black, white, and complementary-colored pieces of paper (i.e., red pepper on green paper) and also on similiarly colored pieces of paper (i.e., red pepper on orange paper), and make exposures of each. Look at all the results and notice how colors work in harmony with, as well as against, one another. (Don't be surprised if the red pepper on the orange paper is your least favorite combo. This is due to the absence of color harmony.)

framing up that same red leaf against an out-of-focus background of similarly colored leaves; that main red leaf appears muddled, bland, almost lifeless in the absence of the right color contrast. When we give the understanding of colors and their relationships to one another the time it needs and deserves, we are soon able to see dynamic color all around us and see how to best exploit it with point of view, lens choice, and light.

▼ **ALTHOUGH ON** this particular day it was rainbow weather (rain and clouds and occasional bursts of sunlight), the only rainbow going on here was the very colorful building in the background and the young girl walking through the scene with her umbrella.

I had just finished having lunch in Little India, Singapore, and it had just started to rain, so I set up my camera under an overhang and waited patiently for people to walk through an open area. This little girl was following her parents, who were walking ahead of her, pushing a baby stroller.

The combination of a slow shutter speed, the angling of the camera, and the moving of the camera during the 1/20 sec. exposure is what accounts for the sense of urgency. The technique of moving the camera at the same speed as the moving subject while shooting at a slow shutter speed is called panning, and the added tilt of the camera creates the diagonal lines you see here.

Nikon D800E, Nikkor 24–85mm lens at 37mm, f/16 for 1/20 sec., ISO 200

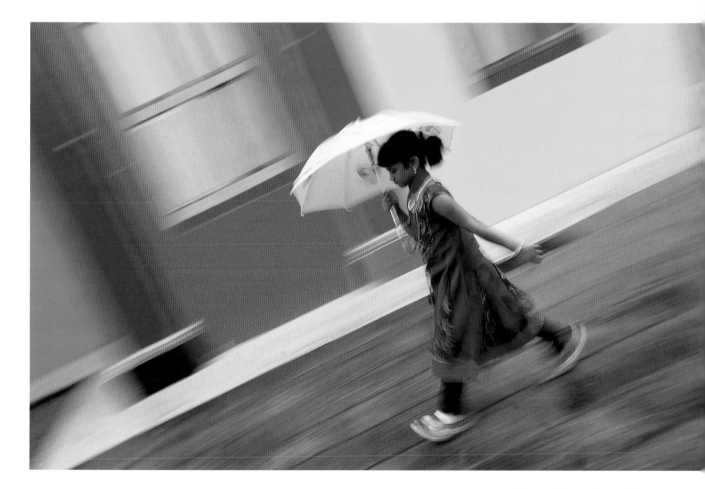

▼ **PHOTOGRAPHING COLOR** for color's sake makes for great fun, and you don't have to go far to do it. A shot like this is easily made on your deck or in your backyard. All you need is a glass baking dish, two large glass or plastic tumblers, and some very colorful fabric. First, place the fabric on a flat surface, like a table. Then place the two tumblers upside down, and put the glass baking dish atop the two tumblers. Now fill the dish with very cold water almost to the top, and then add about ¼ cup vegetable oil. Give the water and oil a chance to settle down, and with your macro lens and camera on tripod, start shooting the many colorful circles floating across the surface of the water. The colors will be determined by your background. I was using a very bright and colorful piece of fabric with red, blue, and yellow in it.

Nikon D3X, Micro-Nikkor 105mm lens, f/16 for 1/30 sec., ISO 100, tripod, cable release

ANOTHER KALEIDOSCOPE of colors revealed itself during an afternoon outing to an outdoor market in Abu Dhabi in the United Arab Emirates. I noticed a number of colorful plastic containers stacked near some large steel pots, and on these pots were many polished dots. The colors of the plastic containers were reflected in these dots. With my 70–300mm lens, I was able to "bring the pot to me" and fill up my frame with this multicolored composition.

Both photos: Nikon D3X, Nikkor 70–300mm lens, f/16 for 1/100 sec., ISO 100

▶ **ONE OF** the more interesting color challenges is to photograph people in surroundings of a similar color, creating a predominately monochromatic composition. It was during one of my New York workshops that I photographed one of my students in a red jacket against a red metal sculpture at City Hall. He made several hand/mouth gestures at my urging, one of which you see here.

It is a powerful image and, in the absence of any real contrasting color, is very monochromatic.

Right: Nikon D800E, Nikkor 24–85mm lens, f/11 for 1/50 sec., ISO 100

▼ **GREEN IS** another one of the recessive colors, and in combination with the blue tattoos, the green takes on an even greater importance in the overall success of this image. Despite the color green being recessive, it is experienced as a dominant element here, and as such, the arm that interrupts this expanse of green becomes the even more dominant subject. All that green gives "power" to the arm. Powerful people usually have an entourage of people "behind" them, like the green fabric here.

Below: Nikon D800E, Nikkor 70–300mm lens, f/8 for 1/250 sec., ISO 200

▲ **BLUE IS** my favorite color, but I seldom come across the opportunity to photograph it, other than when shooting a landscape with blue sky. There aren't a whole lot of blue fruits, vegetables, flowers, fields, and buildings out there.

With that in mind, I became a bit too excited at a tire store upon seeing this large blue wall, with white cracks surrounding the light switch.

Blue is a recessive color, and as such, the much brighter white wall switch creates an even greater illusion of depth and perspective here.

Above: Nikon D800E, Nikkor 24–85mm lens, f/8 for 1/30 sec., ISO 320

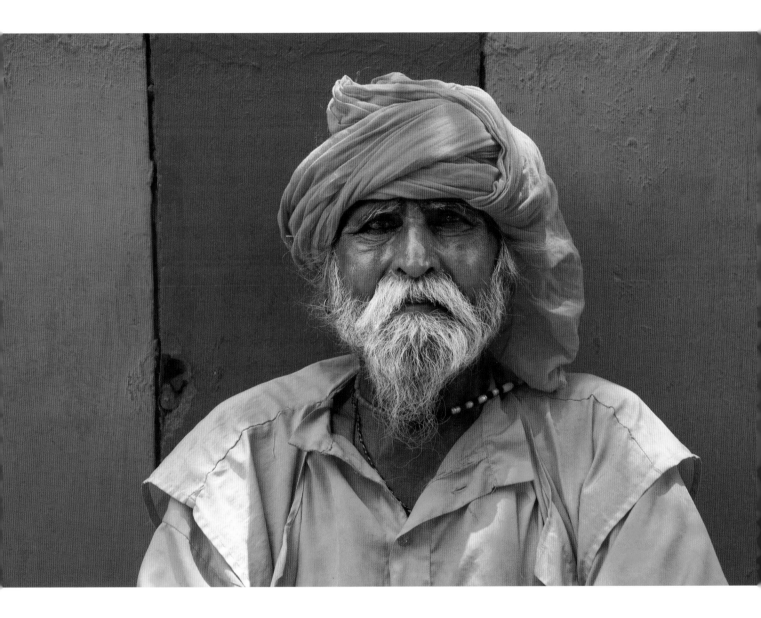

▲ **CONSIDERING THE** amount of orange in this photograph, it couldn't get much warmer than it is! Such is the power of orange. It is symbolic not only of warmth (the sun) but also of a healthy lifestyle—of suntans and orange juice and vitamin C.

It was at a small temple in India where I came upon this man, sitting up against an orange/red wall. Although our conversation was brief, I did manage to find out that he had been coming to this temple almost every day for the past forty-seven years, where he had been meeting up with several friends he went to school with as a young boy.

Nikon D800E, Nikkor 24–85mm lens at 70mm, f/8 for 1/250 sec., ISO 100

▼ **RED IS** the color that advances most, and one of the greatest sources of red is flowers. The spring blooms of red tulips shout "Spring has arrived!" much louder than the spring blooms of pink tulips. Such is the power of red! And when I photographed this lone red tulip, with the slightest touch of yellow at its center, I deliberately turned up its volume by going in close and letting the petals spill beyond the frame **(below)**. Plus, I made a choice to turn the camera on the diagonal to impart a sense of movement and speed. The strong curvilinear lines also add a kind of sensuality here, when combined with the large aperture choice of *f*/5.6 and the subtle soft and limited focus.

Below: Nikon D800E, Nikkor 70–300mm lens with Canon 500D close-up filter, *f*/5.6 for 1/640 sec., ISO 100

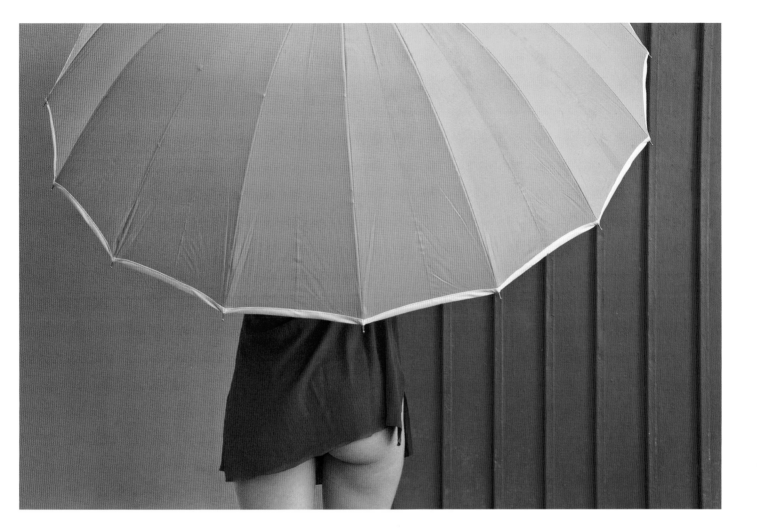

▲ **I AM** a big believer in keeping an eye out for the unexpected, the unplanned, thus allowing two keys for artistic success to flourish: impulse and spontaneity.

Case in point: this opportunity to create a very color-filled composition of magenta and blue was born from a wardrobe malfunction. My students and myself were shooting in Old San Juan, Puerto Rico, with several models. This particular model had just changed into a blue dress when I noticed that the fabric of the dress was caught up on her right side. A second later, she noticed it as well and pulled that part of the dress down. And that is when I raised my voice in an enthusiastic tone, "No, no, no! Seeing your dress hung up on the right side of your waist was actually a good thing!" She trusted me enough to take the shot, which I then quickly shared with her, and she agreed, "Yes, I love this idea, too!" Everybody won thanks to an unplanned wardrobe malfunction and a willingness to let go of the plan and let spontaneity take over.

Nikon D3X, Nikkor 24–85mm lens at 85mm, f/16 for 1/125 sec., ISO 200

▶ **IN GREENWICH VILLAGE,** my students and I came upon a retail space with windows covered in a kind of aluminum foil, and in that foil we all watched a colorful "light show" unfold with the help of various colored jackets and yellow taxis that would pass on the small street behind us. While holding my blue jacket up to the window, I was able to turn the foil from silver to blue, and then I waited for a passing yellow cab—as you can see, the yellow cab is "visible" in the composition of blue **(above, right)**. Notice how the yellow appears to be elevated above the blue in this shot, yet this silver foil in the window is mostly flat with some very small ripples. Such is the power of an advancing color when showcased against the recessive color blue.

Above, right: Leica D-Lux 6, 24mm lens, f/8 for 1/100 sec., ISO 200

▶ **WHEN I** came upon this plywood gate with the spray-painted warning POST NO BILLS, I couldn't resist shooting several of the "stapled" letters, including the letter N that you see on the opposite page. The letter N, with its strong diagonal line, is always on the move, unlike the letter O next to it, which reminds me of a dog chasing its tail.

It's important to note here not just the shape that I chose to photograph but also the colors that make up this shape: bright orange and an almost fluorescent green, atop the calming cool-blue background. The letter N, in this case, is able to "rise" to the occasion due to the advancing nature of its color in contrast to the cool blue.

Opposite: Nikon D800E, Micro-Nikkor 105mm lens, f/13 for 1/125 sec., ISO 100, tripod, cable release

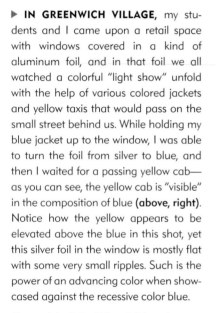

▼ **DURING AN** outing in New York City's Times Square, a heavy rainfall was taking place, and the wet streets lit up like giant Christmas trees.

I set up my camera and 70–300mm lens on tripod and composed an image of the street, along with a section of curb and sidewalk, in order to shoot what was originally going to be a simple abstract shot of reflected color. After zooming out the lens to 300mm, my frame was filled with color, and it was no more than a few seconds before I caught sight of a young woman dressed in colorful pants and pink converse tennis shoes, heading right into my shot. I went quickly to the camera's viewfinder, set my shutter speed to 1/60 sec., and adjusted my aperture until f/7.1 indicated a correct exposure. She stepped into the composition, and I fired away, recording the image you see here. Due to the 1/60 sec. shutter speed, her left foot is a bit blurry since she is clearly on the move.

Below: Nikon D800E, Nikkor 70–300mm lens at 300mm, f/7.1 for 1/60 sec., ISO 200

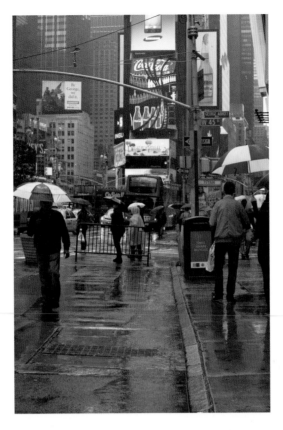

▲ **RISING WITH** the birds in the French Quarter of New Orleans found me walking the streets quite early, and like the birds, I, too, believe that the earliest photographers will have the best pickings.

And to my welcome surprise, I met a local who lived on a bench out in front of the St. Louis Cathedral. I asked if I could take a picture of his collection of rings, and he obliged. Above are two images taken about fifteen minutes apart. There are subtle differences in light, but a major difference in color between the two. In the first image, he was wearing a red scarf, and in the second, he wasn't. (He also had removed one of his rings.) It is another example of how the color red draws our attention, whether we want it to or not.

Both photos: Nikon D800E, Nikkor 70–300mm lens at 240mm, f/8 for 1/250 sec., ISO 100

▶ **A WINTER'S** day in Chicago along Lake Michigan will often reveal the hardiest of runners. On this particularly cold morning, I was in no mood to be out shooting for any length of time, so it was with a tremendous amount of excitement that I took this shot, since the guy was wearing the hoped-for red jogging clothes.

In this instance, that little bit of red is all the color there is, but is it ever powerful in what is an otherwise monochromatic image! I hadn't been out of the car more than five minutes when this guy came across my path, and needless to say, I wasted no time and called it a day within seconds of him moving out of my field of view.

Nikon D800E, Nikkor 24–85mm lens at 85mm, f/8 for 1/200 sec., ISO 400

COMPOSITION

CREATING A STUNNING IMAGE

Perhaps you may find this surprising, but contrary to popular belief, effective "composition" is not just limited to the arts. It would not be a reach to suggest that when our lives are running smoothly it is because the "composition" at the moment is one of harmony—and all harmony consists of the right amount of balance with the right amount of tension. To be clear, the tension to which I refer is a "feeling" of movement, whether real (e.g., a photograph of a child running in a field of flowers) or implied (e.g., the curvilinear line of a country dirt road).

And when our lives are in chaos (no longer balanced), stress results. The duration of that stress might be seconds or days, but it is a human desire to restore order sooner than later. More often than not, we're quick to scramble toward a place where we can reorganize our thoughts and our reactions, thus returning to a more organized and safer "composition."

Unlike the chaos that might be experienced in our daily lives, where no one set of "rules" applies to all, photographic composition *does* center around basic principles called the Rule of Thirds and the Golden Mean. It's my conviction that either of these principles (or both), when practiced, do in fact bring the necessary order to just about any photographic subjects, whether landscapes, cityscapes, seascapes, portraits, sports, fashion, flowers, industry, agriculture, or abstracts.

As photographers, most of our compositions will require us to physically move around to arrive at a pleasing arrangements of elements—i.e., move left, right, up, down, closer, farther back. Granted, this idea of selective composing is purely subjective, since we all "see" a bit differently; so you and I may be seeing the same subject yet both end up with very pleasing but completely different compositions. Perhaps it was a difference in our points of view, or the horizon line placement, or the lens choice, or you getting closer, or me getting farther back. But one thing remains: we both arrived at an orderly and effective composition.

In the *absence* of an orderly and effective composition, the brain responds in one of two ways: (1) it finds the scene boring, lifeless, indecisive, or incomplete (falling short of the right amount of tension and balance), or (2) it finds the scene to be truly chaotic, without order, stressful (oftentimes the result of too much tension and very little balance). The brain, the amazing machine that it is, is quick to recognize order and even quicker to recognize disorder, so let's begin to find out how to bring a sense of order to our photographic compositions each and every time.

FILL THE FRAME

No one will argue that in the arena of compositional shortcomings, the failure to fill the frame is the greatest one that all beginning photographers display. The reasons for this are many, but the main one is the psychological phenomena that makes us blow things out of proportion. The mind is very quick to convince you that you have indeed focused in on a given subject, yet the mind also forgets to tell you that before pressing the shutter you need to take a look to the left or the right of, and above and below, your subject to make certain that you didn't open the door to an uninvited guest. And what is meant by an uninvited guest?

Uninvited compositional guests often present themselves in various and effective disguises. These disguises can be something as simple as contrast shifts or tonal shifts that take on various shapes and sizes. For example, when framing up that frontlit yellow flower against the blue sky, the upper right hand corner of your frame also picked up a snippet of another flower in the background. Not surprisingly, when this flower shows up on your computer screen the brain is quick to see that dark contrast shift from the out-of-focus spot coming from that underexposed flower in the background.

Experience plays a role in spotting these uninvited guests, and the best way to get the experience is, of course, to make a conscious effort to really look for them and find them *before* you press that shutter release. More often than not, it's the photographer's hurried attitude that accounts for many of the uninvited guests, and yet, most subjects are "going nowhere," so learn to slow down and take an extra ten seconds maximum to check that no uninvited guests are showing up.

And what can you do when you find one, two, or three? It's usually a simple matter of moving in a few feet, if not inches, closer to the scene before you. I've said countless times in my workshops, when looking through the camera viewfinders of my students, "You are two feet short of a great shot! Zoom with your feet and walk a bit closer!" You can certainly take that to imply that just when you think your composition is perfect, just when you think you have no uninvited guests, go ahead and shoot, but take one more shot after you move two feet closer to that same subject. I think you'll be surprised to discover that zooming with your feet creates a far more compelling composition.

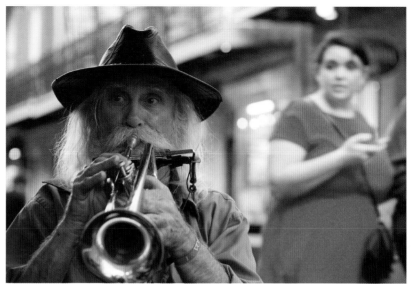

▶ **IT WAS** during a workshop in the New Orleans French Quarter that we saw a number of musicians on many of the street corners. One trumpet player that caught my eye also caught the attention of other passersby, as evidenced by my first attempt at photographing him **(right, above)**. There was a great distraction in the background, and the quickest route to removing her was simply to turn the camera from the horizontal orientation to the less familiar vertical. In the second example **(right, bottom)**, using this vertical position is akin to closing other entryways into my compositional house, thus increasing my odds of showcasing the trumpet player—and *only* the trumpet player—in this frame-filling composition. In switching from the horizontal composition to the vertical, I also needed to move several feet closer or at the least zoom the lens in to a longer focal length in order to maintain my goal of a frame-filling composition.

Right, bottom: Nikon D800E, Nikkor 70–300mm lens at 220mm, f/5.6 for 1/400 sec., ISO 100

▼ **IF YOU'VE** read my other books or participated in my workshops or seen my numerous videos on YouTube, then you are familiar with my mantra when it comes to landscape photography: When shooting landscapes or cityscapes, look for ways to use immediate foreground interest. Doing so will allow you to create compositions that are almost three-dimensional. Looking at this first image of a tea rose bush, the beautiful blue sky with its white wispy clouds, and the Manhattan Bridge in the distance, we cannot help but feel somewhat cheated, as we sense that that one tea rose is just a bit beyond our reach. By walking several feet closer and zooming from 17mm to approximately 24mm, I was able to create a far more intimate composition, suggesting that one might be able to not only feel the texture of the tea rose but also experience its sweet smell.

Below, right: Nikon D800E, Nikkor 17–35mm lens at 24mm, f/22 for 1/30 sec., ISO 200, polarizing filter

HORIZONTAL VS. VERTICAL

I don't know of any investment bankers who would turn down a 100 percent guaranteed opportunity to double their money. Now, I don't have a foolproof scheme that will double your money, but I do have a foolproof scheme that will double your compositional success, and it's almost as easy—and certainly just as quick—as zooming with your feet! What I'm talking about here is the mere act of turning your camera from the horizontal to the vertical position, or what is popularity known as portrait mode.

Simply put, when you turn your camera from horizontal to vertical, you end up with a very similar composition but one whose emotional message goes from being calm and tranquil to being strong, proud, and dignified. Let's take a look at three different examples, and I'm sure it will become immediately clear that these different formats really do convey two distinct emotional messages.

▼ **AS I** drove up through the narrow gravel road toward the peak of Cascade Head, north of Lincoln City, Oregon, I finally broke through the clouds and was greeted by numerous sunbursts of early morning light penetrating the thinner cloud layer. I made a point to not only shoot a number of horizontal compositions but vertical compositions as well. In these examples, the emotional message is subtly different: in both compositions a sense of a spiritual awakening seems to be taking place, but the voice of that spiritual awakening is arguably more youthful in the vertical composition **(opposite)** than it is in the horizontal **(below)**.

When shooting compositions of such strong backlight through a thin veil of low-hanging clouds, I've found great success in the overall exposure by shooting at a 1-stop overexposure from the indicated meter reading.

Both photos: Nikon D800E, Nikkor 24–85mm lens at 35mm, f/11 for 1/400 sec., ISO 100

▶ **MAKING IT** a habit to consider viewing the subject before you in both the horizontal and vertical frame will lead to wonderful discoveries. While I was driving about forty miles outside of Grenoble, France, a thunderstorm unleashed its fury. After the severe downpour, the clouds to the west parted briefly to allow the sun to shine through and leave a rainbow in its wake.

I was quick to grab my camera after pulling over to the shoulder of the road and ran down the road a bit to begin framing up the horizontal scene you see on the opposite page. It seemed only natural to frame up the rainbow and the small village in the horizontal frame, but I was also quick to realize that I wouldn't be able to capture the all-encompassing arc of this particular rainbow due to having only my 24–85mm lens with me and not the much wider 16–35mm. There wasn't time to go back, so I then opted to zoom out the lens a bit farther from 24mm to 40mm and shoot this same scene vertically, and as you can see, I recorded a longer arc **(right)**.

When shooting rainbows, I highly recommend using a polarizing filter: as you turn its outer ring, the colors of the rainbow will become more vivid. When you see this happening, stop turning the ring and shoot away!

Opposite, top left: Nikon D3X, Nikkor 24–85mm lens at 24mm, f/11 for 1/200 sec., ISO 100, polarizing filter

Right: Nikon D3X, Nikkor 24–85mm lens at 40mm, f/11 for 1/200 sec., ISO 100, polarizing filter

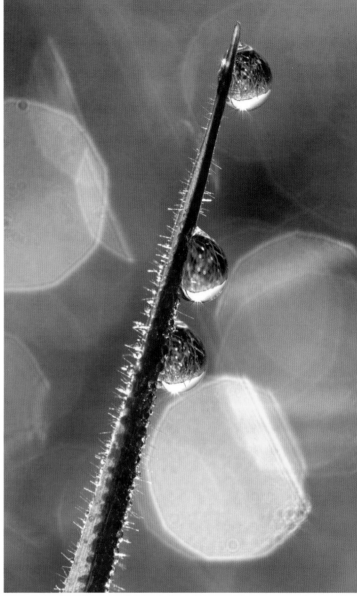

▲ **WHILE PHOTOGRAPHING** this dew-covered blade of grass with a macro lens I had to be several inches farther back to fit it inside the "lower ceiling" of the horizontal frame **(above, bottom left)**. But when I placed that same dew-covered blade of grass inside the "vaulted ceiling" of the vertical frame **(above, right)**, I was able to showcase the strength of its natural vertical shape much more, simply because I had much more vertical headspace that allowed me to focus and move in closer.

Both photos: Nikon D800E, Micro-Nikkor 105mm lens, f/14 for 1/160 sec., ISO 200

▶ **WHILE I** was busy shooting graffiti in an alleyway just a little bit west of the Las Vegas strip, my close friend and workshop assistant, photographer Roger Morin, was busy making quick work of the number 1300 that he had discovered nailed to a wooden utility pole. Shortly after Roger was done, I moved in to make a similar composition as well.

Again, as you can see, I'm presenting you with two versions of that very colorful number, and I'm sure you've noticed that while the horizontal version encompasses the entire number, 1300, the vertical composition allowed me to reinterpret that number as the "unlucky" number 13 **(right, bottom)**. I used the same lens for both as well as the same exposure. I chose f/22 simply because the subject was on a circular wooden pole and was therefore not at all parallel to the digital sensor; due to this curvilinear distance falloff, a much smaller aperture choice was required to capture the needed depth of field.

Both photos, right: Nikon D800E, Micro-Nikkor 105mm lens, f/22 for 1/15 sec., ISO 100

THE RULE OF THIRDS

Although it took some time, many of today's DSLRs are equipped with LCD screen grids that help photographers achieve compositional balance. In addition, there are specific leveling tools that you can call upon, either within the viewfinder itself or by choosing a specific selection on the digital monitor. The combination of these two tools can enable the photographer to frame up most any subject with perfect compositional success. The most common grid found in many DSLRs is the one that looks like a tic-tac-toe grid and makes it very easy for photographers to implement the Rule of Thirds (a simplification of the Golden Mean).

I advocated for years for camera manufacturers to design a Rule of Thirds viewing screen back in the film days, and I'm pleased to see that they have finally done so on most DSLRs. (Of course I had nothing to do with these grid screens showing up on DSLRs, but whoever is behind this, I applaud you!)

If for no other reason than to keep your horizon lines straight, get in the habit of having this feature turned on either inside the viewfinder or on the back of your monitor.

Since a compelling photograph is more often than not about an effective arrangement rather than about the content, are there "rules" or guidelines for creating the most effective and engaging composition? Interestingly enough, there are. I call them "the rules of engagement," and they are referred to as what the Greeks called the Golden Section, later named the Rule of Thirds.

The Golden Section refers to a mathematical calculation that equals 1⅔ or 1.66. Although there is ample evidence that the Golden Section was in use by the Egyptians, for example in the building of the pyramids, it wasn't until ancient Greek mathematicians began studying the paintings of their fellow artists that they began recognizing a "pattern"; objects in a scene were often two-thirds as large as others, landscapes often placed the horizon line with two-thirds of the landscape below and one-third sky above (or vice-versa), and in still lifes, artists seemed to favor compositions in which two-thirds of the frame was filled with the round shapes of fruit and the remaining third with the round shape of the bowl. It's safe to say that these artists and architects had a "natural eye," an innate sense about how to create compelling and effective compositions. Thanks to the Greek mathematicians, namely Pythagoras, this compositional arrangement became known as the Golden Section, a rule stating that when any object or shape had two distinct parts, the smaller should be one third the size of the larger, e.g. one third sky versus two thirds of the frame being filled with the red barn, white fence, and fall trees.

What is perhaps most interesting about the Golden Section is that nature abounds in it. Who needs mathematicians if you have a keen eye? Every living and breathing thing in Mother Nature's closet, from flowers and ferns to the smallest microbe, is evidence of the Golden Section. Even the human

skeleton is full of the Golden Section; my upper arm bone is roughly two thirds the length of my lower arm bone.

Entire books have been written about the Golden Section and discussing it here in detail is beyond the scope of this book, but it is vitally important that I state emphatically that the use of the Golden Section in your compositions will more often than not lead to far more engaging and compelling photographs.

Golden Section, Rule of Thirds, call it what you want, but it's another great excuse to "turn on" the "rule of thirds" grid that is often included with all DSLRs these days. This grid shows up on the back of your monitor or inside the camera's viewfinder, and if ever there was a tool that was close to "auto-composition" this would be it. Why more shooters don't employ this tool on their camera is beyond me!

To be clear I do not believe that we must be bound by the Rule of Thirds—or what I, with great affection, have been calling for years, the Suggestion of Thirds. At its core, this "grid" can serve you well! If nothing else it will help you keep your horizons straight and as one who has critiqued thousands of images over the years, crooked horizons are not only distracting but unfortunately the norm for many shooters!

▼ **THE MAIN** difference between how many beginning photographers compose and what the Rule of Thirds suggests has much to do with the placement of the main subject and the horizon line. As you can see in this first example, the horizon line (or at least the suggestion of the horizon line) runs through the middle of this photograph. The bottom half is composed of red poppies and purple lavender fields, and the top half is composed of a hillside of pine trees and a touch of sky. Right smack-dab in the middle of this landscape is a stone house. Contrast this with the next composition in which the horizon line falls near the top third of the frame and there's an absence of pine trees and sky. It's safe to say that this is a great improvement. Some may argue that the house shouldn't be in the center, but moving my point of view so that the house was on the left or right meant including unwanted objects in the frame. (Note that my camera was on tripod, and I used a polarizing filter to reduce the harshness of the midday sun falling on the landscape.)

Both photos: Nikon D3X, Micro-Nikkor 70–300mm lens at 300mm, f/16 for 1/60 sec., ISO 200, polarizing filter

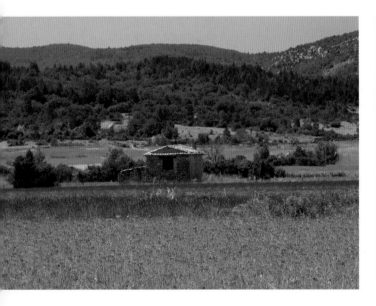
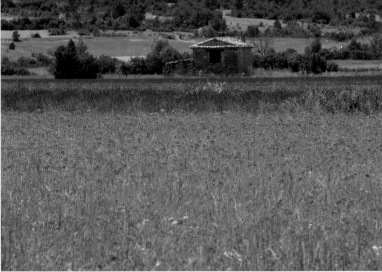

▶ **IN THESE** next four examples, I have placed a Rule of Thirds grid atop each photograph to illustrate how using the Rule of Thirds creates both tension and balance. It is my suggestion that you turn on that grid feature on your camera and use it until it becomes a permanent part of your vision.

In this first example of a small lizard clinging to a wall, I was able to take advantage of an obvious line on that wall and use it as a way to distribute the overall visual weight in the composition. Clearly that line is coming in on the left third of the overall composition, thus dividing the frame into a one-third and two-thirds split. Just to the right of that line is the small lizard. Its position and its suggested direction, heading into the frame, also account for positioning all of that extra room in the two-thirds section of the frame, because the eye and brain can now assume the lizard has plenty of room to run.

Both photos: Nikon D3X, Nikkor 24–85mm lens at 35mm, f/11 for 1/125 sec., ISO 200

▲ **IN THE** first example of a young boxer **(top row)**, I was deliberate in framing him up inside a doorway, and in much the same way as I did with the lizard, I utilized the red wall and blue door trim as a dividing line of one-third/two-thirds.

In the following example of the young woman **(middle row)**, I chose to tilt the camera at a moderate angle to elicit a subtle sense of movement and speed. Notice how she is encompassing two-thirds of the overall frame, and how the top third line is running right through her eyes.

In this last example **(bottom row)**, I placed my main subject within the first vertical third of this horizontal composition. This illustrates another point, which is that the dominant subject does not have to physically dominate the composition in order for the eye and brain to figure out what the dominant subject is.

In the case of this photograph taken in Jodhpur, India, I chose a composition that showcased a tremendous amount of blue, and amongst all of this blue would be my subject. I was fortunate that in this particular location, a background window and wall offered up some welcomed contrast.

Opposite, top row: Nikon D800E, Nikkor 24–85mm lens at 85mm, f/8 for 1/200 sec., ISO 400

Opposite, middle row: Nikon D800E, Nikkor 70–300mm lens at 130mm, f/6.3 for 1/320 sec., ISO 100

Opposite, bottom row: Nikon D800E, Nikkor 24–85mm lens at 30mm, f/16 for 1/100 sec., ISO 400

▼ **HOW DID** I manage to find myself on the second floor of this private home of an Indian family? The previous evening at my hotel, my waiter and I struck up a lengthy conversation about India and America's relationship. It was lively, to say the least, and subsequently resulted in my receiving an invitation to spend an afternoon at this young man's house with his mother, father, several aunts and uncles, a sister, a brother, and a grandfather as well. I knew that invitations like these often allow for some extremely intimate photographic opportunities. You're no longer a stranger on the streets of a foreign land but rather an honored guest.

Among the many photographs I made that afternoon, my favorite is this one of the waiter's mother and his two aunts. They are sitting casually atop a twin bed in an upstairs bedroom, and because the upstairs had ample available light through several large windows and several large skylights, the use of the flash wasn't necessary. And with three subjects, the Rule of Thirds was remarkably easy to employ. Plus, the added contrast of numerous colors contributes to making this a very eclectic image.

Nikon D800E, Nikkor 24–85mm lens at 35mm, f/8 for 1/45 sec., ISO 200

▼ **IN CONTRAST** to the photograph of the three Indian women, where the three parts of that photograph are running predominantly as three vertical "human" lines, here we see three dominant tones or lines that are running horizontally. These lines appear here as tones and textures, but because of their placement inside the horizontal frame, they are also a bit more subdued than the colorful tones and textures in the image of the three Indian women.

To make this shot, I focused one-third of the way into the scene and, with my camera on tripod, fired the shutter using the camera's self-timer with a 5-second delay.

Additionally, these horizontal bands of tones and textures are cast into a supporting role, as the real star of this photograph is the road sign indicating curves ahead.

Nikon D800E, Nikkor 70–300mm lens at 300mm, f/32 for 1/15 sec., ISO 100

▲ **IN MANY** photographic compositions, the eye/brain is quick to pick up on any suggestion of movement, and there is much debate on where in the overall composition that suggested movement should be placed. Let us take a look at these two examples of a pigeon perched just outside its home on a brick wall in Puerto Rico. In the first example **(above, left)**, the pigeon and position of its head are inside the stone frame, and the bird seems to be looking to the right, as if something has caught its interest outside the frame. Note how the next image is in sharp contrast and is perhaps a bit more unsettling. In the Western world when we read a magazine or a book, our eyes move from left to right—this learned flow of left-to-right movement would seem to account for our desire to see suggested movement in a composition also flow from left to right. In the second example **(above, right)**, the position of the pigeon and the direction in which it's looking are in direct contrast to what feels normal in Western society. Yet when viewed in countries such as Japan, this same photo would be much preferred over the first, simply because the Japanese view the world from right to left, a habit that begins in their youth when first learning to read. Personally I don't have a problem with one or the other, nor do I have a preference, but I will add that this is due in large part to the fact that both photographs have succeeded in filling the frame with a clean composition of texture and shape.

Both photos: Nikon D3X, Nikkor 24–85mm lens at 80mm, f/8 for 1/320 sec., ISO 100

FRAME WITHIN A FRAME

One of the ways to create a tremendous amount of depth and perspective in your photographs is to combine the use of a wide-angle lens with great depth of field, being certain to employ immediate foreground interest. Another way is to use a moderate telephoto lens, such as a 200mm or 300mm, making a point to focus through an immediate foreground subject and focusing on the main subject that might be five to ten feet away. When done so at a wide-open or nearly wide-open aperture, the resulting out-of-focus colors and tones that surround the focused subject again create a feeling of depth and distance. The end result in either case is that you end up with a composition that has several layers of interest from front to back.

But another technique that doesn't rely on a wide-angle lens with immediate foreground interest or a telephoto lens with an extremely shallow depth of field is the technique that I call *framing within a frame*. This is using foreground subject matter to call attention to, and frame, the main subject in a photo. Framing within a frame, when well executed, often produces an above-average composition. Perhaps because it's a favored compositional choice of mine that I often seek out opportunities to frame within a frame, but whatever the reason, I'm rarely disappointed by my attempts at utilizing this principle.

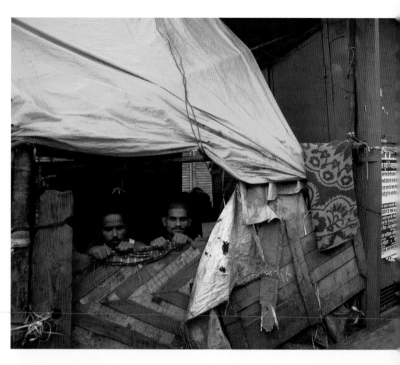

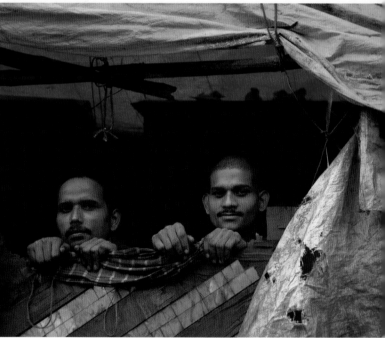

◀ **I HAD** spent most of the day in the Chandni Chowk market of New Delhi, and my eyes were quick to notice these two young men sitting inside a very colorful enclosure. Following several brief minutes of conversation, I directed their attention toward the camera. I also directed their position within the frame, asking them to move a bit to the right and to put their hands on the edge of the short wall. Because of the somewhat large area of dark open shade behind them, I made a point of moving in close with my camera and lens, filling the frame with just one of the gentlemen's faces. Having already set my aperture to f/8, I adjusted my shutter speed for the light reflecting off of their faces and found that 1/60 sec. indicated a correct exposure. Obviously I didn't want the meter to be influenced by the darkness, which is why I moved in and took my meter reading off of one of the gentlemen's faces. The purpose of framing within the frame is to call attention to the main subject that lies inside that frame.

Opposite, bottom: Nikon D800E, Nikkor 24–85mm at 85mm, f/11 at 1/80 sec., ISO 200

▼ **IN THE** first shot here **(below, top)**, you can clearly see two things going on: (1) a portrait of a young woman wearing a head scarf against a background of out-of-focus color, and (2) the use of the frame within a frame technique. I will share with you that I struggled a great deal with this initial composition, as I was hell-bent on combining the out-of-focus background colors from blooming trees with a portrait of the young woman. But it wasn't working, primarily due to a color conflict. I abandoned the idea and went with what was not so obvious initially but became obvious later: the real shot here was simply the beautiful young woman and a composition that made use of the framing-within-the-frame technique courtesy of her head scarf **(below, bottom)**.

Both images: Nikon D3X, Nikkor 70–300mm lens at 120mm, f/6.3 for 1/250 sec., ISO 200

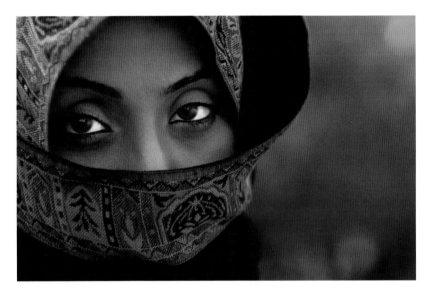

BREAKING THE RULES

In many areas of life some rules, no matter how well intended, are simply meant to be broken. In photography, there are also a number of exceptions to compositional rules, and of those, I want to call particular attention to two: filling the frame and always using the Rule of Thirds. And regarding the Rule of Thirds, if not broken certainly challenged.

I began this chapter by calling your attention to the need to always, always, always fill the frame, yet I'm about to tell you why that is not always a good idea! In these examples, it's clear I've fallen ridiculously short of filling the frame, assuming that the subjects are the people. Yet the purpose of choosing a super-wide-angle lens was to render the person in both of these shots as small and distant to create a frame-filling composition of size and scope. Aha! So in effect, I'm still filling the frame, but in this case, I'm filling the frame with the environment, and when the I showcase the surroundings with a lone person in the composition, I evoke a sense of isolation and even humility.

◀ **AFTER BEING** dropped off by helicopter in one of the most remote regions of the Bugaboo mountain range in Canada, several of my students and I began to trek along a ridgeline of snow. As I looked back at one of my students, David Kennedy, I called out to him and suggested that he move closer to the edge of the ridgeline and walk as I shot several exposures, one of which you see here **(opposite)**. If there wasn't a person in this photograph, it would surely beg for one! And because the human shape is unique, we are left with the unmistakable realization that this is a vast and "empty" place.

Opposite: Nikon D3X, Nikkor 16–35mm lens at 16mm, f/22 for 1/320 sec., ISO 200

▶ **FOLLOWING SUNSET,** the sky lit up with deep magenta and orange hues, and thankfully, the low tide left in its wake numerous small pools of water along the sandy shoreline. It was then that I asked my son, who had joined me for the day along Oregon's coastline, to walk into the scene and stand among the distant rocks with his arms outstretched. It's fair to say that the human shape not only lends an important point of interest but also adds a welcome sense of scale. And in this case, due to the outstretched arms reaching toward the sky, one is left wondering what the person in this photograph is giving thanks for.

Both photos: Nikon D800E, Nikkor 17–35mm at 21mm, f/22 at 1/8 second, 100 ISO

LENS FLARE

I didn't use f/22 for depth-of-field reasons but rather to achieve the starburst effect in the sun that you see on the opposite page. Your lens will also determine how much lens flare you might record, but as a helpful tip, I tell all of my students to remove *all* filters when doing this "trick," as the filters will reduce if not eliminate the lens flare normally associated with shots of this type. (Lens flare is seen as those numerous hexagonal shapes of varying sizes that pepper your composition when you shoot directly into the sun.)

▼ **SPLITTING THE** frame into two equal parts is seldom a good idea, but in the case of reflections, what choice do you really have? This is an exception to the hard and fast Rule of Thirds and is one of the many images I've made in West Friesland, Holland. I've made a number of photographs of one particular windmill during the spring since it's here where you can see the sun rising up from behind the windmill, oftentimes reflecting in the nearby dike. In all of my years of photographing this particular windmill, it wasn't until the spring of 2014 that I witnessed the most remarkable sunrise I had ever seen. There had been a heavy fog that morning and I was uncertain if it would thin out at sunrise to allow the sun to be visible. Fortunately, the fog thinned out just enough for me to capture what was one of the quietest mornings I've ever experienced in this area of Holland. I have never titled an image in all my years of shooting, but in this case I made an exception, and have titled this image *SHS (Silent Holland Spring)*.

Nikon D800E, Nikkor 70–300mm lens at 90mm, f/8 for 1/250 sec., ISO 200, FLW magenta filter

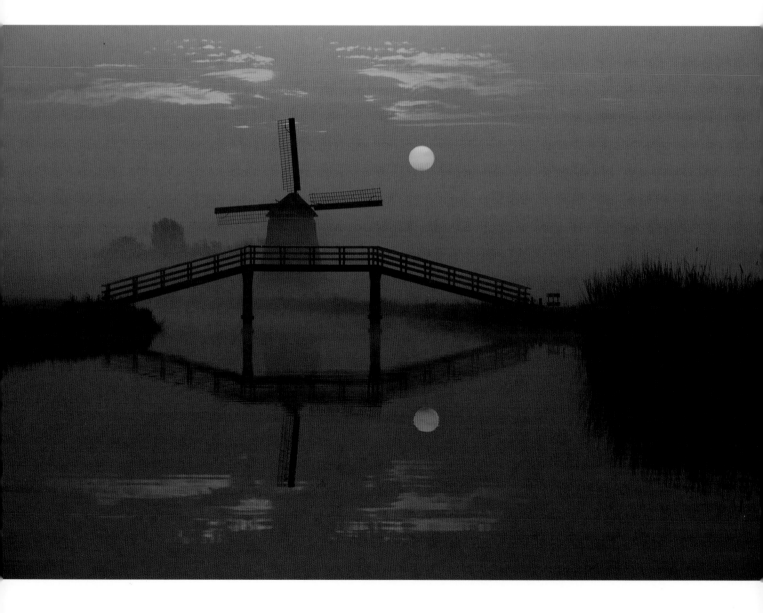

▶ **ONE MONTH** after I made the wind-mill image **(opposite)**, and 4,300 miles to the west, I photographed this young girl at Millennium Park in Chicago as she approached one of the powerful gushes of water that are seen coming out of mouths on various portraits on lit glass blocks making up two large obelisk-like sculptures. There really was no other choice but to split the frame into two equal parts, and again, not surprisingly, this choice was being applied to a composition that included a reflection. If we further analyze the success of this image, it becomes clear that the balance is indeed due to the 50/50 split, and the tension comes from the frozen "gesture" of the young woman, a gesture that suggests she's in the midst of an unfinished act.

Nikon D800E, Nikkor 70–300mm lens at 220mm, f/11 for 1/100 sec., ISO 400

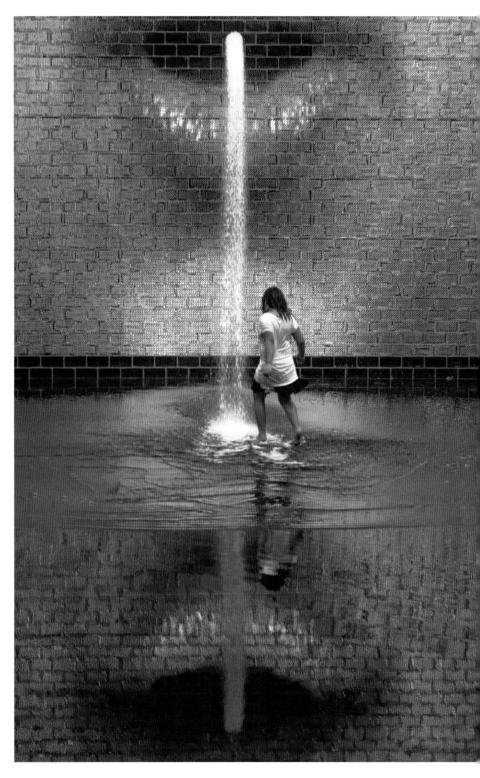

PICTURE IN PICTURE

Without fail, if there's one technique that will double your success in the area of learning to see, it's this thing I call *working your subject*, and it begins with a really simple question: Now that I've made that one compelling shot, what other compositions are possible within that initial compelling image? More often than not, there is at least one additional shot that will be revealed by calling on the telephoto lens or by using the same lens but simply moving in closer ("zooming with your feet").

▶ **COMING UPON** a field of flowers several years ago, I pointed out to my students that the combination of large cumulus clouds and blue sky would create a landscape of rolling shadows and sunlight. As we set up with our cameras on tripod, preparing to shoot the lone tree, the field of flowers, and the distant hills, a large swath of shadow began rolling over the middle sloping hill you see here, and since the exposure is set for the sunlight, the hillside in the shadow is rendered quite dark. I then suggested that we switch to the telephoto lens so that we could gather up an additional photo of just the tree and field against the contrasting backdrop of the hillside in shadow.

Top: Nikon D3X, Nikkor 24–85mm lens at 35mm, f/11 for 1/500 sec., ISO 200

Bottom: Nikon D3X, Nikkor 70–300mm lens at 220mm, f/11 for 1/500 sec., ISO 200

▶ **NO MORE** than ten miles north of the town of Siem Reap, Cambodia, I found myself immersed in the many small villages that lend themselves to a far more intimate experience. I met this woman at the local pharmacy, where she was hoping to get help for a severe cough that had been keeping her awake for most of the past week. I noticed that she had a small sack of mandarins and asked her if she might hold them in her hands while I made an up-close-and-personal portrait of her with the help of my Nikkor 24–85mm lens. Then with the same lens, I made the second composition you see here, but using a different focal length and a slightly different point of view.

Top: Nikon D3X, Nikkor 24–85mm lens at 85mm, f/16 for 1/100 sec., ISO 200

Bottom: Nikon D3X, Nikkor 24–85mm lens at 28mm, f/11 for1/200 sec., ISO 200

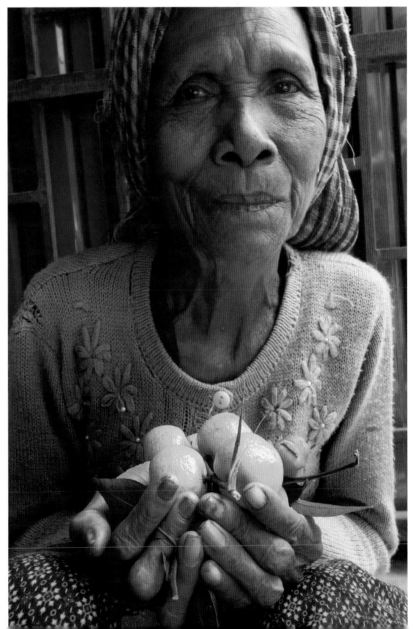

▶ **THIS HOUSE** was under a large area of open shade, and this open shade is what accounts for the somber blue and turquoise tones seen here. On this particular morning, it was remarkably clear, and the blue sky overhead was also imparting a blue color cast in the Barrio, a revitalized neighborhood just south of downtown Tucson.

With my Nikkor 24–85mm lens, I was quick to make this simple composition of the door that you see here. Note the contrast of welcome color both by the placement of the artificial flowers on the door and the planted flowers on the left side of the frame. Prior to moving on, I felt compelled to make an additional photo, a horizontal image, of those artificial flowers and the white letter box contrasting with the surrounding blue and turquoise colors of the door.

Right: Nikon D800E, Nikkor 24–85mm lens at 35mm, f/11 for 1/30 sec., ISO 200

Opposite, top left Nikon D800E, Nikkor 24–85mm lens at 65mm, f/11 for 1/30 sec., ISO 200

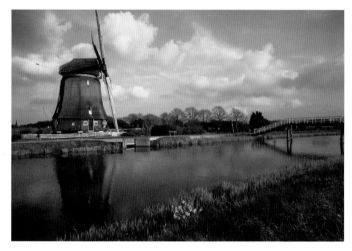

▲ **WITH MOST** wide and sweeping landscapes, we are quick to get seduced by their appeal and just as quick to frame them up, fire off a few exposures, and then move on, failing to see the many other images that lie within. The possibilities here are many, but one particularly compelling image that stood out for me was the simple reflection near the lone clump of blooming daffodils.

Standing at the edge of the dike, I mounted my camera and 24–85mm lens on the tripod, and since there was no immediate foreground interest, I chose an aperture of f/11 and simply adjusted my shutter speed until 1/200 sec. indicated a correct exposure for this sidelit scene. Normally, I would call on a polarizing filter for a sidelit scene, but I didn't want to diminish the reflection of the windmill on the water, which a polarizer would certainly do.

I then picked up the tripod, moved in closer to the clump of daffodils, and carefully chose the "cleanest" point of view that would allow me to also include the rippled reflection of the windmill. As you can see here, this second shot is no doubt a different take on the same scene, but one thing is clear in both of these compositions: they are both unmistakably Holland!

Above, bottom left: Nikon D800E, Nikkor 24–85mm lens at 24mm, f/11 for 1/200 sec., ISO 100

Above, right: Nikon D800E, Nikkor 24–85mm lens at 70mm, f/11 for 1/200 sec., ISO 100

CONTRAST

As you gain more and more visual experience in your quest to learn how to see, another area that will eventually grab your attention—and, subsequently, your need to be even more aware of compositional problems—is this thing called contrast.

Contrast in its simplest of definitions means how one thing compares to another thing within the frame of your photograph, and comparison is the key here. Contrast cannot exist alone. If I have a composition of a fork photographed on a white background in soft, even light, and I then told you that the fork was more than six feet long, you would have no choice but to take my word for it. On the other hand, if I stood the fork up on end and had a six-foot-tall man holding it, you wouldn't need me to tell you that the fork is unusually large since our experience with the size of the fork is in direct *contrast* to the size of the man, which in turn tells us that the fork *is* huge.

Another example of contrast is easily seen when we photograph a red pepper on a green background; that will result in a high-contrast image versus the low-contrast image of that same red pepper when photographed against a red background.

Size and color contrasts are worthy of discussion, but so is tonal contrast—i.e., shifts in light and dark. The more intense the shift in light to dark or dark to light, the higher the degree of attention that part of your scene will get. As described earlier in the section on filling the frame, depending on its importance to the overall composition, a slight shift in tone can be upsetting to the eye and brain, in much the same way that spot of ketchup on the white shirt shouts, "Hey, look at me!"

The reason excessively dark and/or bright tones are not initially seen by the beginning photographer is because our human eye is a wonderful machine that can actually encompass a range of approximately 16 full stops. When looking through the viewfinder, this amazing machine with its 16-stop range fools you into thinking that you don't have any excessively bright or dark areas in your scene. Yet upon pressing the shutter release, if you look carefully on your digital monitor you will, in fact, see some subjects with these excessively dark areas or excessively bright areas that are in marked contrast to other areas throughout the photograph. And the greatest challenge *after* you have identified these many contrast shifts is to now decide how they will be distributed across the frame.

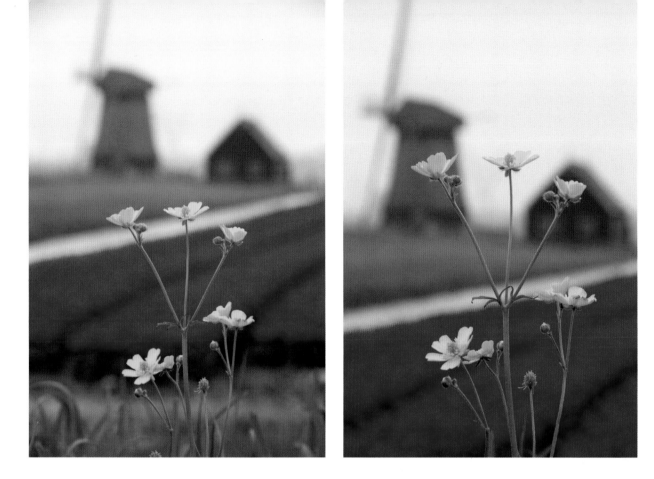

▲ **AS YOU** look at these images, which do you feel has the greatest impact? And are you clear as to the reasons why? In both images, the visual weight is clearly on the yellow flowers, leaving the windmills, the small house, the field of tulips, the narrow dike, and the field of green rendered as out-of-focus shapes and tones.

As you look at the first image **(above, left)** and compare it to the second image **(above, right)**, it becomes apparent that a change has taken place. Not only did I zoom my Nikon 24–85mm lens from the 35mm focal length to the 55mm focal length, but I also made minor shifts in my point of view that would deliberately place all but one of the yellow blooms against contrasting tones in the background. It was no accident that we see two of the yellow blooms against the dark tones of the house and windmill, and it was no accident that we see two of the blooms against the field of red. I made these shifts in my point of view all in the name of contrast.

In the first image, the inclusion of all of that green grass in the bottom third of the composition pulls the eye down and away from the field of red tulips and the distant windmill. And not surprisingly, we are disappointed once we are asked to look at this area, since there really is nothing of interest in all that green. Next, as we look at the potential contrast of the yellow in-focus flowers against the out-of-focus background, I take issue with the flowers that are in front of the gray contrast of the dike. It is my feeling that these yellow flowers need to be contrasted against a darker color, not a lighter color.

Above, left: Nikon D800E, Nikkor 24–85mm lens at 35mm, f/6.3 for 1/400 sec., ISO 200

Above, right: Nikon D800E, Nikkor 24–85mm lens at 55mm, f/7.1 for 1/320 sec., ISO 200

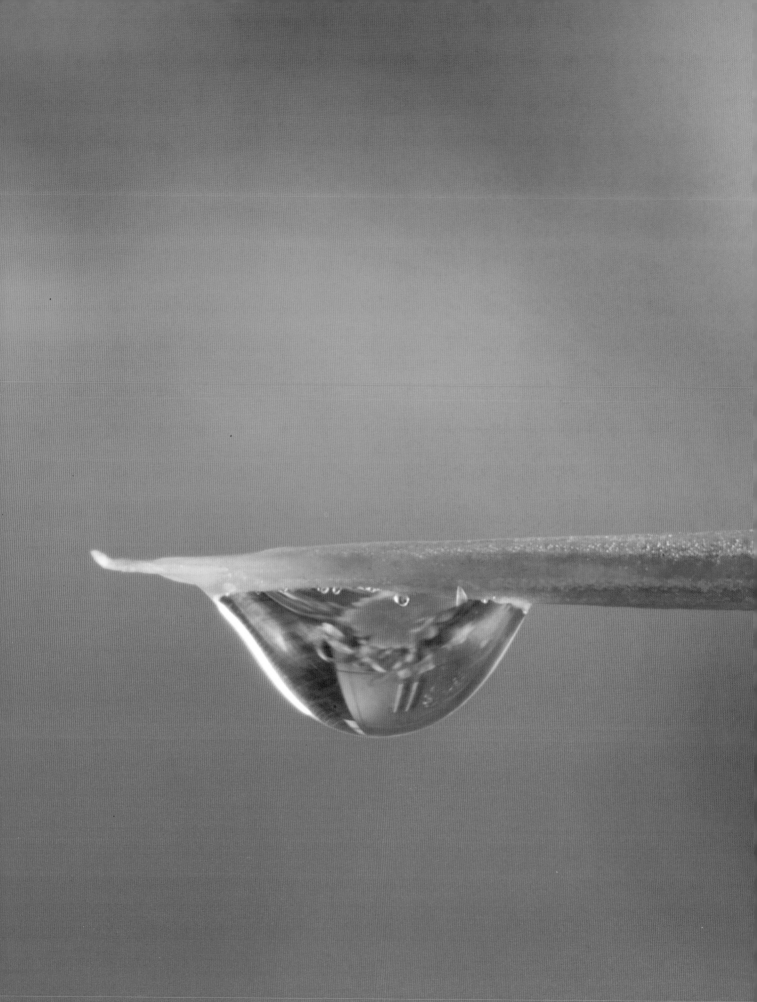

THE MAGIC OF LIGHT

EXPLORING LIGHT

Although this book does showcase a few examples of combining natural and artificial light, it is my belief, at least in the initial stages of learning to see, that a rudimentary understanding of natural light needs to be explored if only to fully understand *why* certain times of day are more favorable than others to be out shooting.

The time of day and your position vis-à-vis the sun determine a lot about how your subject will appear in the available light: with hard or soft edges, in warm or cool tones, and displaying vivid details or glaring contrasts. Light has three important characteristics: brightness, color, and direction. All three undergo varying degrees of intensity, again depending on the time of day, and each affects the mood created by the available light in any given scene. Careful study of these three attributes will enable you to take advantage of the powerful roles they play in establishing a photograph's emotional tone.

You must often pay a price for being passionate about presenting your subjects in the best available light possible. Arriving at a location when it's only you and the songbirds filling the air with sound may be difficult for those who hate mornings or anxiety-provoking for others who don't feel safe when out alone. But, if your intent is to return home with the "trophy" you must be willing to go outside of your comfort zone. Hanging out under the hot desert sun or ascending a mountaintop in subzero temperatures to capture the special quality of light takes commitment. But when you open up your image on your computer or run your slide show across the computer screen, you will not only be reminded of why you made the effort but your audience will surely speak of you as one who has "vision"!

Whenever I arrive someplace new to take photographs, I'm anxious to get my bearings: east, west, north, and south. I've had great success by visiting tourist shops in airports and bus stations, where I buy postcards and those local souvenir picture books; then, I go looking for a cab driver, hotel concierge, or even the locals sitting on a park bench, and with my map in hand, I ask where the various pictures were taken. Then, I spend the *midday* hours looking for fresh viewpoints of those same subjects. If everything goes as planned, I photograph them under the best possible light—early a.m. or early p.m., depending on the subject and its location. Scouting for compelling images at midday takes commitment, of course. Normally, this is the time to shop, be poolside, or simply sit under a tree reading a book. But there's nothing worse than being caught off guard and discovering a great shot at the wrong time of day with the wrong light.

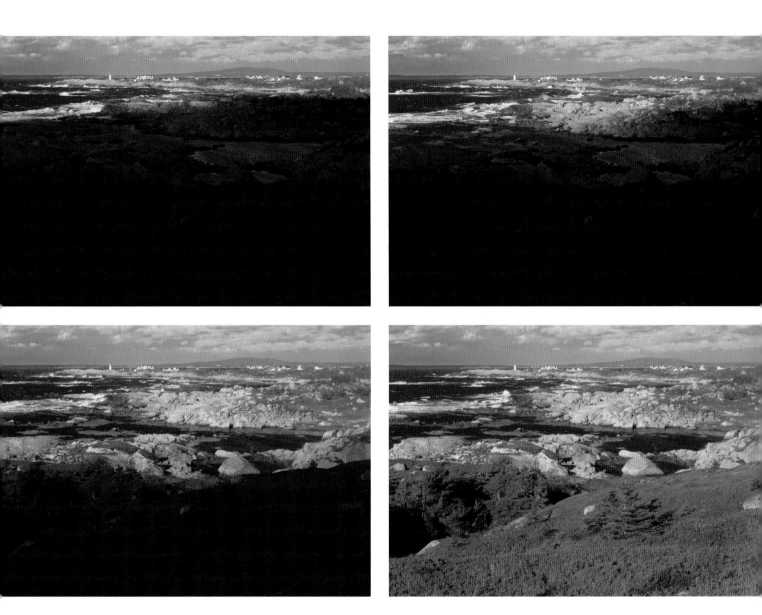

▲ **IT IS** one of my fondest lighting conditions when shooting landscapes: a combination of large, white, puffy clouds and blue sky with moderate winds that push the clouds along and create pockets of light and shadow.

This was the case on this day as I stood out on a small bluff near Peggy's Cove in Nova Scotia a few years ago. With my camera and 70–300mm lens mounted on tripod, and my exposure set for a sunny day, I started shooting a series of images as a large cloud moved across the sun, hiding and then revealing the cheerful morning light.

All photos: Nikon D800E, Nikkor 70–300mm lens at 180mm, f/16 for 1/200 sec., ISO 200

▶ **BY DAY,** the World War II Memorial and the Capitol **(top row)** look "normal," since both of the views on this page were taken under "normal" mid-afternoon light. Shooting at this time of day will reveal the scene that most are familiar with, but when you reveal what most everyone is already familiar with, how can you call yourself a lighting magician, since you haven't created any "tricks"?

Top: Nikon D800E, Nikkor 24–85mm lens at 24mm, f/16 for 1/200 sec., ISO 200

Opposite, top: Nikon D800E, Nikkor 70–300mm lens at 260mm, f/22 for 1/125 sec., ISO 320

▶ **AS THESE** next two examples demonstrate **(bottom row)**, low light is far more capable of creating a great image than normal light. Yes, both of these examples were shot at dusk, when most shooters are eating dinner, watching TV, or going to the movies. How do I know? Because at 2 p.m., I was able to easily count well over a hundred photographers who shot these two iconic locations, yet when shooting at dusk, I was able to count on one hand how many photographers were out shooting.

As is true with lens choice and point of view, the more experience you get working with available light, the better your photographs will be; this *is* an undeniable truth!

Bottom: Nikon D800E, Nikkor 24–85mm lens at 35mm, f/16 for 8 seconds, ISO 100

Opposite, bottom: Nikon D800E, Nikkor 70–300mm lens at 260mm, f/22 for 16 seconds, ISO 100

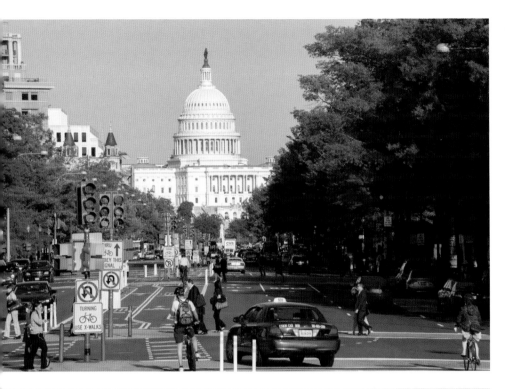

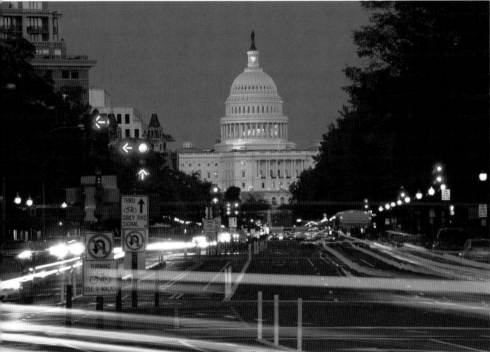

As you work, you'll learn to assess a subject's potential under various lighting conditions, regardless of the light in which you initially see it. Even a daily awareness of the light around you—in the city, suburbs, countryside, or wherever you may live—will bring you closer to learning to see creatively. Photographing the same scene two evenings in a row is a great visual exercise yet the reason most shooters don't do it is because of a "been there, done that" philosophy.

No matter where you live, try to make it a point to shoot the same scene, two days in a row, either thirty minutes before sunrise or twenty minutes after sunset, and make the discovery that there often is a remarkable difference in the light.

◉ EXERCISE : The Quality of Light

Try this exercise, which will reveal what is really meant by the *quality* of the light. Staying as close to home as possible, find a location that lets you face *east*, and head there in time for the sunrise. With your street zoom (see page 20) set to a focal length near 35–50mm and shoot a composition into the sunrise. Shoot the same composition one and two hours later, then at noon, then two hours before sunset, then one hour before sunset, and finally at sunset.

Repeat this exercise during these same intervals with another composition, but as you face to the *south*. At the end of the day, if you're working digitally, download the images to the computer and fire up a slide show. Spread the images across the light table once they're processed if you're using slide film, or out on a table if you're shooting color print film. Independent of subject matter, you will really see and feel the difference of the light and the difference that the "right" time of day can make.

▼ **SHOOTING THE** harbor of Peggy's Cove on two consecutive evenings resulted in two completely different photographs, at least in terms of their appeal. The first night, the sky was much more of a dusky blue. It had been very windy most of the day, keeping the skies clear of small airborne particles that often account for those colorful sunsets we all love.

Yet when I returned to the same spot on day two, following a day of no wind, the sky was far more magenta due to airborne particles. I'm not suggesting that one of these shots is better than the other, but if you are a fine art photographer who sells your work, this exercise does prove that in shooting the same scene at least twice, you will be able to offer your clients a choice.

Both photos: Nikon D800E, Nikkor 24–85mm lens at 52mm, f/11 for 4 seconds, ISO 100

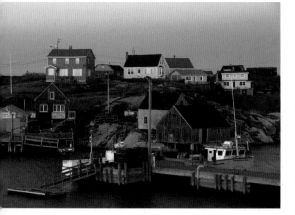

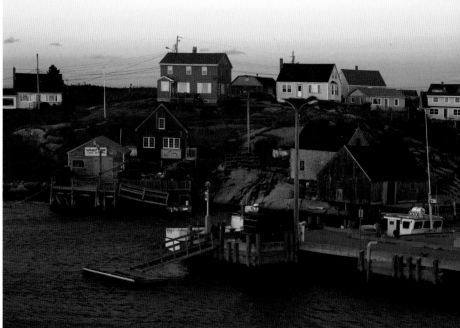

THE DIRECTION OF LIGHT

When the sun is low in the sky, whether in morning or late afternoon, your subject will be either frontlit, backlit, or sidelit, depending on your position relative to both your subject and the sun. *Frontlighting* occurs when the sun is at your back and hits the front of your subject (i.e., whatever part of the subject that's facing you). Note that this is not the time of day or type of light in which to shoot frontlit landscapes with a wide-angle lens, as your shadow will intrude into the composition and be captured by the wide, sweeping vision of the lens. To avoid having your shadow appear in the image, you must either wait until the sun is higher in the sky, use a normal or telephoto lens, or change your position and consider shooting the scene in sidelighting.

Sidelighting is by far the most dramatic, as it creates an exciting tension between highlights and shadows. It occurs when the sun is to the side of both you and your subject. Sidelighting produces shadows that bring a wonderful sense of depth to a scene, and it emphasizes subject texture. It is also the *only* time you will gain the maximum benefit from using your polarizing filter.

▲ **I LOVE** to shoot portraits against the background of out-of-focus tones of green. On this particular day, the sun was at a low angle in the sky, and I wasted no time in placing Charles, a neighbor of my brother, directly into the sun, against the frontlit maple tree. The distance between Charles and the tree is about thirty feet, the perfect distance when combined with my focal length of 200mm and an aperture of f/6.3 to render the tree into out-of-focus green tones. As you can see here, Charles is 100 percent frontlit against an equally frontlit maple tree.

Nikon D3X, Nikkor 70–200mm lens at 200mm, f/6.3 for 1/1,000 sec., ISO 200

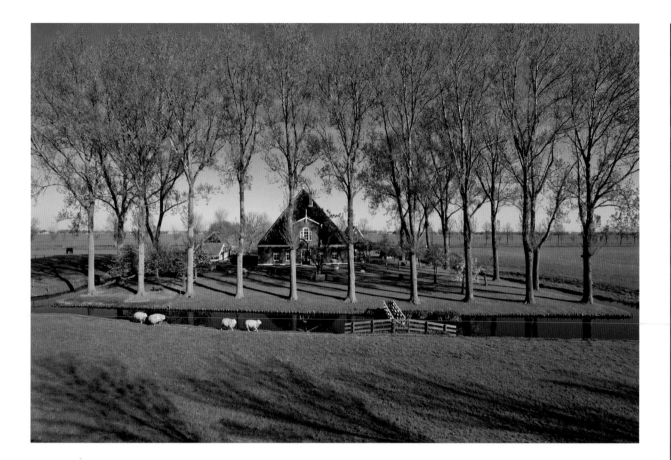

▲ **AS YOU** probably realize by now, I love West Friesland, Holland, and this particular scene continues to be one of my favorite locations to shoot. It's a solitary house surrounded by tall trees, a small dike, and the ubiquitous sheep grazing along the small hill that lines the dike. It has looked this same way since I first came upon it in 1985, almost thirty years ago! At this time of year (spring), the late-afternoon low-angled sunlight bathes the house and trees in warm sidelight, rendering long flowing tree shadows across the green grass, creating a welcome sense of depth and dimension.

Nikon D800E, Nikkor 17–35mm lens at 17mm, f/11 for 1/125 sec., ISO 100, polarizing filter

If you want to get your face suntanned while working, then backlit subjects are for you. *Backlighting* occurs when the sun hits your subject from behind and falls directly on your face as you photograph—you can't shoot backlighting unless you are facing right into the sun. Most backlit subjects are rendered as silhouettes. In effect, backlighting reduces your subjects to stark, dark, bold shapes. It is not limited to early-morning and late-afternoon light; you could easily position yourself under a power line at midday and photograph straight above you into the sun to silhouette the fifty blackbirds perched there. Transparent subjects—such as leaves, feathers, and balloons—are also exciting subjects for backlighting, as the illuminating effect will showcase any intricate details and colors.

◄ **I ENJOY** shooting images of other photographers, as my students will attest. On this particular morning, one of my students, Dan Carlson, was shooting the sidelit Chicago skyline as the sun came up over Lake Michigan, and heck, I live in Chicago and have shot that same skyline more than thirty times. But I *haven't* shot a photographer against the rising sun over Lake Michigan, so shooting Dan was the obvious choice. Again, we know very little about our subject other than his telltale shape. Silhouettes, as you know, are all about shape, and the most common way to record a silhouette is against backlight!

Nikon D800E, Nikkor 70–300mm lens, f/11 for 1/640 sec., ISO 100

THE COLOR OF LIGHT

The color of daylight varies according to both the time of day and the weather. The midday sun produces an often-harsh, white light. The overhead position and colorless quality of this light mean you are least likely to capture emotion-filled and dramatic lighting at this time of day, which is why so many experienced photogaphers prefer to shoot early in the morning and late in the day.

Just before dawn (and for about twenty minutes after sunset) in good weather, the light produces a clear sky with cool blue and magenta hues or rosy pinks and vivid reds. Beginning right at sunrise, this is replaced with an unmistakably warm, orange light that bathes frontlit and sidelit subjects in various tones of orange and gold. Usually beginning about one hour before sunset and lasting up to sunset itself, this color change occurs in reverse. This sunset time is referred to by many photographers as the *golden hour*, implying that this is truly the most magical hour of the day for shooting.

I would agree with this if I hadn't made a regular habit of rising at dawn to see morning light, too. Having photographed numerous subjects during the *morning* golden hour as well as the sunset golden hour, I can say that both are magical times to work. Yet, what I have found interesting is that when I share my work with fellow pros, the almost universal response is, "It's obvious that, like me, you favor the last hour of daylight." I know I'm not the only one who has discovered that morning light has a

golden hour, too, but evidently there are still a lot of photographers out there who don't realize it. Truth be told, I've noticed that most photographers aren't morning people, and that's too bad, since making a habit of taking pictures in *both* of the day's golden hours, day in and day out, will produce twice as many winners.

▲ **ALL THREE** of these photographs are the same in terms of lens choice and point of view but radically different in their color. I used no filters and the same white balance throughout, so why the difference? Because of the *color* of the light in each. The much bluer light of dawn accounts for the first image **(top, left)**; the sun was still twenty minutes from rising. When it does rise it casts a warm glow across the scene, as seen in the second photograph **(top, right)**. Seasoned photographers are quick to argue that *this* is the best light in which to shoot! It doesn't last long, as the third photograph **(bottom)** was taken only thirty minutes later than the second.

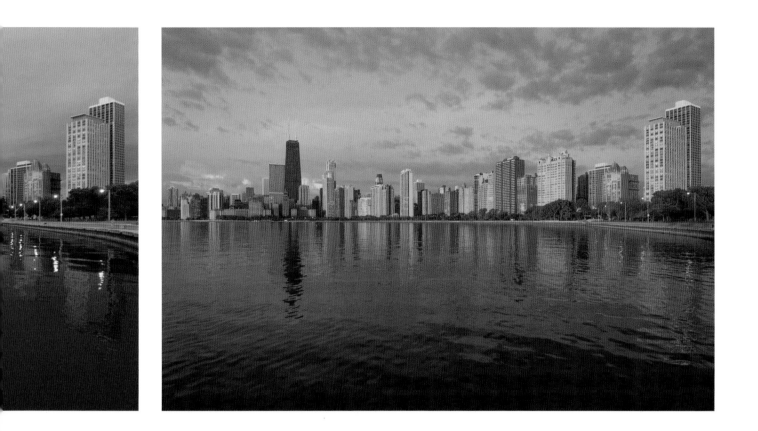

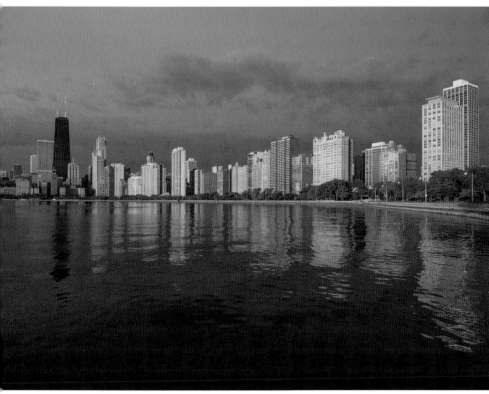

Top, left: Nikon D800E, Nikkor 24–85mm lens at 30mm, f/11 for 4 seconds, ISO 200

Top, right: Nikon D800E, Nikkor 24–85mm lens at 30mm, f/11 for 1/8 sec., ISO 200

Bottom: Nikon D800E, Nikkor 24–85mm lens at 30mm, f/11 for 1/50 sec., ISO 200

OVERCAST AND RAINY DAYS

Although the argument for working only during the golden hours is a strong one, don't be seduced by it. There are countless opportunities to capture compelling subjects when the skies overhead are a sea of gray clouds, with or without rain. The much softer light of a cloudy day creates much richer colors, so this is a great time to shoot in your garden. Prove it to yourself by shooting some flowers on a cloudy day and then returning to shoot those same flowers when the sun is out. The results will speak volumes about the value of working under an overcast sky as you take note of the ease of setting your exposure in the absence of the plentiful contrast present on sunny days.

This is also a great time to photograph people. In this softer light, you don't need to worry about under-eye shadows or about your subjects squinting into the sunlight. Are you often frustrated by exposures of extreme contrast when working in the forest? Go on a cloudy day! In my opinion, sunny days are the worst time to be in the woods, since the combination of light and dark is often so extreme that no amount of bracketing will ever produce a compelling image. Save the forest for overcast days, and don't forget to use your polarizing filter. Particularly on rainy days, the polarizing filter will reduce, if not eliminate, much of the dull glare that reflects off the many wet surfaces in forests under those conditions. Rainy days are a magical time in cities, too. Colorful umbrellas abound, and the streets are a reflection lover's paradise.

The only things I would suggest avoiding when shooting on cloudy or rainy days are landscape or forest compositions that include too much of the gray sky. More often than not, the inclusion of a dull sky will only hurt the image, no matter how strongly you may feel it balances the composition. Why is this? Simply because the extreme shift in mood from the soft greens of the forest and trees to the harsh and glaring white/gray of the sky is far too contrasty. It's like listening to soft music while there's a car alarm going off in the background.

▶ **DURING A** New York City rainstorm I was able to take cover quickly in a bus stop shelter, and it was there that I took notice of an advertisement under hard plastic that featured a young woman. It had been raining off and on, and some of that day's moisture had managed to find itself caught on the inside of the plastic. Choosing to do a really close crop to create a bit more of a graphic composition, I called upon my Nikkor 24–85mm lens and focused quite close, arriving at the composition you see here. Again, the soft light of the cloudy day made for an easy exposure—the kind you could easily shoot in Aperture Priority mode if you wished.

Nikon D3X, Nikkor 24–85mm lens at 85mm, f/8 for 1/60 sec., ISO 200

◀ **SILVER FALLS** State Park is Oregon's largest state park, and autumn continues to be a very popular time to visit with its vine maple explosion of color along with the big leaf maples, too. Of the eleven waterfalls at the park, the upper North Falls continues to be one of my favorites to shoot.

With my camera and 17–35mm lens on tripod, I set the aperture to f/22 and preset the focus to 1 meter for maximum depth of field. With my polarizing filter turned so that the gray glare that was reflecting atop the water and other wet surfaces had been eliminated, I adjusted my shutter speed until 1/2 sec. indicated a correct exposure. With the camera's self-timer engaged, I tripped the shutter release and, following a 5-second delay, the exposure was recorded.

And to be extra clear, Mother Nature had other things on her mind on this morning, since the distribution of autumn leaves was sparse in this scene before me, so I helped her out by gathering up a few leaves and placing them on the rocks.

Nikon D800E, Nikkor 17–35mm lens at 19mm, f/22 for 1/2 sec., ISO 100, polarizing filter

PHOTOSHOP

PUTTING PHOTOSHOP TO WORK

As my online school and workshops bear witness, the liberal use of Photoshop continues to divide the photographic community. When the revised edition of *Learning to See Creatively* was published in 2003, I estimated the percentage of photographers who used Photoshop liberally in their workflow to be in the neighborhood of 15 percent, which of course meant that 85 percent of the photo community was only using it minimally.

Fast-forward twelve years, and those numbers have easily flipped; no less than 85 percent of the photo community is now using Photoshop or Lightroom or Aperture as part of their workflow and many are also using numerous plug-ins with these programs quite liberally.

To be clear, I continue to be old school in many ways, and my old-school approach has much to do with not only the number of years I have been taking photographs but also the environment that surrounded me when I first picked up a camera. When I started in 1970, we were just beginnning to see cameras with built-in light meters that offered "wide-open metering." I was also *not* a fan of black and white, so I didn't have a darkroom, but I did have my trusty light table, on which I would lay out my Kodachrome slides, and with the aid of a loupe, I was able to determine steps to take the next time I was faced with a difficult exposure situation. And because I was shooting slides, getting the right composition *in camera* was extremely critical! When showing work to prospective clients during all of the 1970s and through the late '80s, I loaded up a tray of slides and presented a short slide show, each image having to stand on its own.

Fast-forward to 2014 and the "benefits" of Photoshop are truly too hard to resist. Today, when you screw up and your exposure is too bright or too dark, no problem—Photoshop can fix that! Today, when you forget your colored filters, no problem— Photoshop can fix that! Today, when you forget to walk closer to the subject or fail to use the right lens, no problem! You have a 24MB sensor! Heck, feel free to call on Photoshop and crop away, up to 50 percent of your image if you want. That still leaves you with an image that is equivalent to one taken with a camera that has a 12MB sensor, and we all know that it was just a few years ago that we were all shooting with "a full-frame 12MB sensor"!

I purposely bring up just a few of these Photoshop "benefits" for a reason: they are *none* of the reasons why I feel Photoshop should be used. I'm a fervent believer in the "organic experience," in "getting it right in camera." Getting it right in camera is really a simple proposition, and the lessons to be learned from getting it right in camera are invaluable *when* you actually do take on Photoshop. (I say *when* to those remaining 15 percent, and trust me, there's a *when* in your future, too!)

If you were going to live in a foreign country, would you agree that it would be a great benefit to you to invest your time in learning how to speak, at least at a basic level, the language of the country to which you were moving? Or would you simply

download a translator app that can do the talking and translating for you?

I'm making the argument that you should invest the time to learn how to set a basic exposure in camera, since this will lead to a greater appreciation of which exposure tools to use in that foreign country called Photoshop. I'm also making the argument that you get in the habit of checking all four corners of your frame *before* you press the shutter release, before you move on to the next shot, and do whatever is necessary to fill that frame; move left, right, lower, or higher, and either get a bit closer or move a bit back. I value my time a great deal, and if I can get the exposure right at 1/125 sec. *in camera*, why wouldn't I? When I sit down in front of the computer, there are only four reasons why I find Photoshop extremely valuable, and two of these have a great deal to do with my ability to *expand* my creativity: First, I shoot raw images, so I must use Adobe Bridge to open each of those raw files. (Lightroom and Aperture can also be used to process raw files.) Second, I use *one* tool—Selective Color— religiously in my postprocessing, and it has much to do with my prior use of the color slide films Kodachrome and Fujichrome. Both of these films were great at producing deep and vivid color, and I have found Selective Color (Image>Image Adjustments>Selective Color) to be the *only* tool that renders and re-creates the deep and vivid color from my slide film days without any degradation to the pixels.

And that leads me to the third and fourth reasons, the use of Adjustment Layers and Layer Masks, both of which have *increased* my ability to be far more creative than I ever thought possible. It is these four reasons alone that allow me to voluntarily conclude that I really cannot live without Photoshop! Knowing what I know about the potential for layers has, on many a night, kept me wide awake or found me jumping out of bed to grab pen and paper to write

down and/or sketch my latest ideas that will hopefully one day be brought to fruition because of Photoshop.

At present, I have no interest in actually making images in Photoshop "from scratch," which I know is of course possible; but rather, my interest is in creating a complete image from incomplete images. What constitutes my idea of an incomplete image? Maybe it was a cloudy day and I wanted a sunny day, or it was a clear sky day and I wanted a stormy sky. Maybe it was cloudy the night of the promised full moon. Maybe I would like to see a desert as the foreground against the backdrop of the Seattle skyline, instead of the familiar Puget Sound. Maybe I would like to move the old weathered barn from Vermont onto the cliffs of the Oregon coast . . .

If there's one key to the successful use of creating "impossible exposures" or "unreal landscapes or cityscapes," it is that they look believable, and of course, that means that everything you know about shooting images *in camera* must follow you into Photoshop. You are more likely to be successful when doing a simple foreground exchange (swapping the foreground in one image for the foreground in another) when you know about lens choice, perspective, point of view, and, of course, light and exposure. These are all things you learn from being out on a street corner or along the edge of a stream in the forest time and time again. Photoshop does *not* teach you anything about lens choice, for example, but it certainly screams loud and clear when you don't get it right: adding a full moon taken with a 300mm lens to a landscape that was shot with a 24mm lens looks anything but natural, for example.

Photoshop doesn't teach you about the direction of light either, so when you take a frontlit person from one shot and place him or her into a sidelit landscape, it will look "off." So again, invest the necessary time behind your camera and lens, and

learn how to see perspective and point of view. Spend time shooting a number of various exposures, and learn all there is to learn about light and dark. And of course, spend time just simply observing both natural and artificial light. Note the shadows or the absence thereof. Note how light is warm, cool, yellow, or blue. But most of all, and especially with the addition of Photoshop in your arsenal of creative weapons, start asking more and more the questions *What?* and *What if . . .?*

What can you do with that incredible frontlit sky of large cumulus clouds and patches of blue? Why not replace that frontlit "boring" clear blue sky in that image you shot the other morning of the Manhattan skyline from Brooklyn Bridge Park?

What can you do with the heavily textured bark of an oak tree? What if you did a simple Blending Layer of the texture with someone's portrait, if they were both captured on a day of overcast?

What can you do with that old rusty nail sticking up through a weathered board? What if you placed the board and nail on a cross-country runner's trail, and with the camera and a moderate wide-angle lens mounted on tripod, you frame up the board and nail in the foreground and fire off the first frame. Then move the board out of the way and, with the tripod in the same position and using the same lens, have a runner come through, shooting several takes. And then upon returning to the computer and with the aid of a Layer Mask, you show his foot within one-eighth of an inch of coming down on that rusty nail? Ouch! (Shoot this idea on an overcast day instead of in sunshine; otherwise, you'll have a hard time explaining why his foot and the nail are both in full sun since under normal conditions his foot would be casting a shadow over the nail.)

What can you do with all that crashing surf hitting the rocky cliffs on a day of a coastal winter storm? What if you photographed your wife or husband or friend or neighbor running toward you with great fear in their faces and you then placed them out on those same rocks, as if they were running for their lives from the large and looming oncoming waves?

Yes, I know it sounds like I'm a bit "bent," so to show you that I really am a well-balanced guy, what can you do with that open single red rose? What if you photograph it with your macro lens and then photograph your sleeping three-month-old. Then, in the tradition of the photographer Anne Geddes, "wrap" your baby in the "blanket" of rose petals?

PHOTOSHOP HOW-TOS

One of the great advantages of technology and the Internet is my ability to share with you videos of the actual processes of every one of the following ideas I'm about to share with you. I've included the before and after images here and now invite you to go online to http://bpsop.com/learntoseecreativelyvideos.aspx to see each step in the process of turning these ordinary images into something extraordinary.

▶ **PIZZA ANYONE?** Before placing my camera and full-frame fish-eye lens at the back of the oven, I engaged the camera's built-in flash, setting it to rear-curtain sync. I then set the camera to Aperture Priority mode, choosing an aperture of f/16 to generate the required depth of field, and prefocused the camera to its shortest focal point of 4 inches. (Autofocus was turned off, as usual.) In addition, I engaged the camera's self-timer to fire 5 seconds after first pressing the camera's shutter release. All that remained was to explain to the model that he needed to just stand there for a few seconds acting as if he was about to take the fresh-baked pizza out of the oven. (Getting my model to do exactly as I directed was the easiest part of the shoot since the model is me!)

For those who don't know about rear-curtain sync, here's how it works, in capsule form: instead of the flash firing at the beginning of the exposure, it fires at the end. So for this example, with the camera in Aperture Priority mode, the initial exposure was taking into account the daylight that was outside the oven, and at the end of the 1-second exposure time, the flash fired and illuminated the interior of the oven.

Now, did I actually set my camera and fish-eye lens into a 400-degree oven? Of course not! The oven is at room temperature. So how do I explain the red-hot coils overhead and the steam rising from the pizza? I made a simple Color Balance Adjustment Layer in Photoshop by adding red and a bit of magenta, thus turning the normally gray oven coils to a glowing red. And I then added the steam to the pizza with a low-transparency white with my paintbrush set to 25% with white as my color.

Nikon D300S, Nikkor 16mm Fish Eye, f/16 at 1/8 sec., ISO 200

▼ OLD IRONSIDES I came upon this old, rusty iron pipe in the harbor at Peggy's Cove. I was drawn to the pipe because of its varied and numerous textures, yet after shooting the composition you see here with my flash from the side, it occurred to me that this could actually be seen as a large rock or even a tall cliff. It wasn't until a year later when I finally found several scenes that I could easily layer with this iron pipe, both of which you see here. The first is an image of the Bugaboo mountains. After being dropped off via helicopoter at an elevation of about 8,000 feet on this cloudy summer day, I made quick work of the distant mountains with my wide-angle lens and a low point of view. I wasn't impressed with the end result, but after I combined this shot with "old iron-sides," I thought this just might be the missing link.

A few months later, after shooting a few rock climbers at some distance in Red Rock Canyon outside Las Vegas, I had another reason to call upon "old ironsides." As you can see in this exam-ple, I'm creating the illusion that the rock climber is indeed ascending a very large and tall cliff!

Landscape image: Nikon D300S, Nikkor 24-85mm at 24mm, f/22 at 1/8 sec., ISO 200

Pipe image: Nikon D300S, Micro-Nikkor 105mm, f/32 at 1/200 sec., ISO 200

CRYING OVER SPILLED MILK. My students and I were shooting near Ground Zero in New York City when I happened to turn around to make sure we were all together. I noticed the wall with what I'm guessing are ventilation openings and asked one of my students to walk past these openings and express a bit of shock and surprise, as one might if someone had dumped coffee or a glass of milk out onto him while he was walking on the sidewalk below.

On returning home, I had my daughter Sophie pour a glass of milk outside my studio under the same overcast lighting conditions. Then following the creation of a simple Layer Mask, I got an image of Sophie's arm pouring a glass of milk onto one of my students, who, as I am sure you agree, has every reason to be shocked and surprised!

Man image: Nikon D800E, Nikkor 24-85mm at 37mm, f/11 at 1/200 sec., ISO 320

Milk image: Nikon D800E, Nikkor 17-35mm at 28mm, f/8 at 1/1000 sec., ISO 200

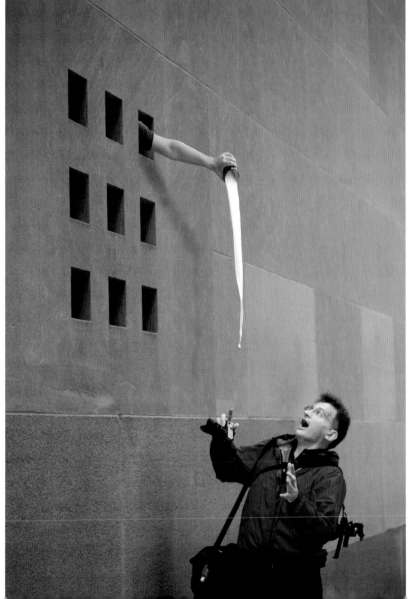

▼ HIP HIP HOORAY! I have no doubt that if you were to spend just a few hours going through the images on your computer or external hard drives, you would find a number of images that when combined or layered with another, would result in a number of new and exciting photos. It's a way to challenge just how you will "see" once again!

I had photographed these kids lying on the sandy beach on the Jersey Shore about seven years ago and had also shot these cheerleaders at a cheerleader competition in San Francisco about ten years earlier! Little did I know they would one day become one. The key to the success of this shot is that everything must be to "scale." With the

help of the Layer Mask, along with the use of the Transform tool in Photoshop, I was able to create a whimsical image that suggested the kids were throwing the cheerleaders straight up into the air.

Hand image: Nikon D2X, Nikkor 17-35mm at 28mm, f/22 at 1/100 sec., ISO 200

Cheerleader image: Nikon D300S, Nikkor 24-85mm at 28mm, f/8 at 1/1000 sec., ISO 200

◄ LOST YOUR HEAD. We've all been heard to say, "I'd lose my head if it wasn't so securely attached to my body!" Well at least in one case, it looks like this "scuba diver" just might have lost his head! When I first came upon this scene in the town of Cassis, France, just east of Marseille, I was amused by seeing nothing more than a wet suit hanging outside of an apartment in this narrow passageway **(above, right)**. It wasn't until several years later, when I had shot a friend of a friend in Palm Beach, that I discovered an exciting way to bring that hanging wet suit back to life—sort of.

Among the various shots I had made on that afternoon in Palm Beach was this one **(above, left)** of him jumping over his daughter. Little did I know then that this image would provide the perfect set of hands and feet to "fit" inside the hanging wet suit, *sans* head! Yes, of course it is dark humor, and thanks to Photoshop, I'm looking forward to creating many more such quirky images.

Jumping image: Nikon D300S, Nikkor 17-35mm at 22mm, *f*/11 at 1/1000 sec., ISO 400

Wetsuit image: Nikon D300S, Nikkor 35-70mm at 35mm, *f*/13 at 1/60 sec., ISO 200

◄ **"SAY WHAT?!"** If there is one tool in Photoshop that is called upon more often than not for the wrong reason, it is the Clone Stamp tool! Yes, I know it is used by a lot of photographers to clean up their images and/or to add some additional subject matter, but rarely is it ever called upon to change the meanings of words that bombard all of us every day. Advertising is everywhere, including this subtle advertisement on the Greek island of Santorini. I asked one of my Greek students what was written on this bench, and he said, "Sunsets!" That made sense to me, since this was an area where the sunset would be visible, but I couldn't resist the temptation a few months later to reword this bench into something a bit more humorous. As you can see, it now says, "I love salami!"

Nikon D2X, Nikkor 24-85mm at 24mm, f/16 at 1/1000 sec., ISO 200

CLONING IN PHOTOSHOP

Cloning is a technique that allows you to duplicate any section of a photograph in other areas of the photograph. For example, with the Clone Stamp tool (it looks like a rubber stamp), you click on the object or area you wish to duplicate somewhere else in the photo and, after clicking on that object, you simply move the mouse to that other area and click again—and, voilà, you have moved one letter, as in the case **(above)** from here to there!

▼ **DOUBLE TAKE.** Another one of my often-called-upon tools in Photoshop is the Canvas tool. In effect, the Canvas tool allows you to increase the area around the size of your original image. Where you want this "extra" image area to be will be determined by where you place the original image inside the square that comes up when you call up the Canvas tool menu.

I shot this reflection of the sunset in Peggy's Cove, and it wasn't until later that I was hit with the idea of making a duplicate image in Photoshop, then flipping it, and, with the aid of the Canvas tool, making both a sunrise and sunset image; at least that was the idea, and after sharing this idea on Facebook, I'm convinced it worked, as many fellow photographers let me know they had to do a double take to figure out what was actually going on here.

Nikon D800E, Nikkor 17-35mm at 19mm, f/22 at 1/30 sec., ISO 100

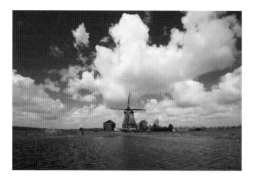

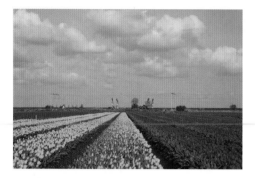

▼ **REPLACING PONDS WITH TULIPS.** One of the greatest frustrations for the travel photographer is arriving at a given location and finding out that the Brooklyn Bridge or the Eiffel Tower is enclosed in scaffolding, or that the fields of tulips in Holland are blooming everywhere *but* in front of that classic windmill!

Such was the case for me several years ago, and the best thing I could find was a windmill with a large pond in front of it. I knew immediately when I took this intial image that I would layer it with a field of tulips in Photoshop. Since I shot this initial image with my Nikkor 17–35mm lens at 20mm, I would also need to shoot the field of tulips with the same focal distance. And since this windmill was frontlit, I, again, would need to make certain to shoot my tulip field frontlit. As you can see here, both images are in fact frontlit, and combining them took all of three minutes with the aid of a simple Layer Mask.

Both images: Nikon D800E, Nikkor 24-85mm at 24mm, *f*/16 at 1/80 sec., ISO 100

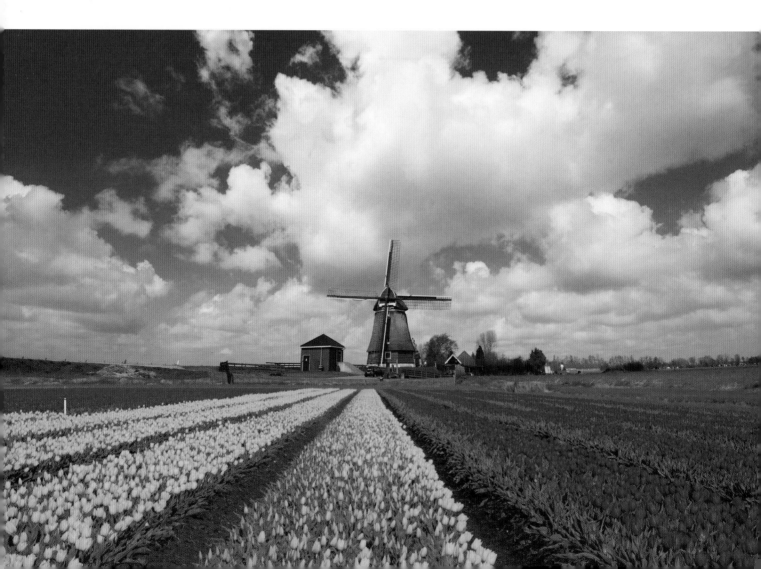

▶ **ALL EYES ARE ON YOU.** Along Oregon's beautiful coastline I spent the majority of a morning shooting these wonderful patterns in the sand near the edge of a small stream that fed into the ocean. The strong backlight of the early morning light really emphasized the textures and form of these patterns that morning, but it wasn't until later that it occurred to me that one of these shapes was like a profile of The Grinch and with the addition of the eye, made possible by a simple Layer Mask in Photoshop, The Grinch really comes alive, in a very "creepy" way perhaps!

Below: Nikon D300S, Nikkor 70-300mm, Canon 500D close-up filter, f/22 at 1/200 sec., ISO 200

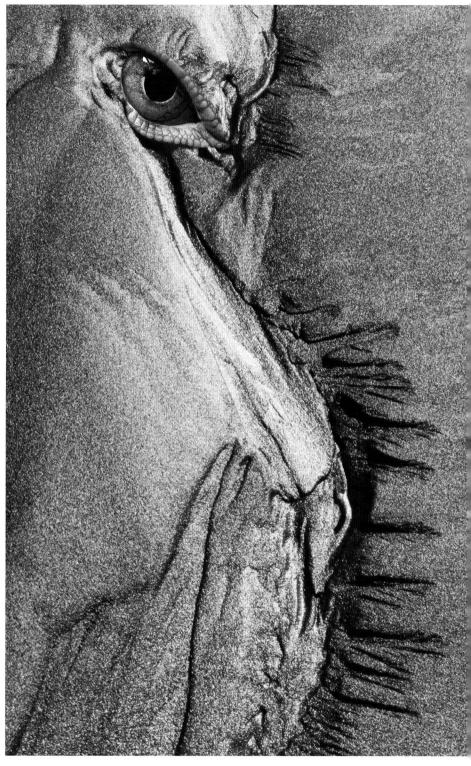

CONCLUSION

As I now find myself reviewing all that I have written on the subject of "seeing," it is even more apparent that there is far more I would have, should have, and could have said, but space is always limited when writing any book. It is my enthusiasm for image-making that accounts for my desire to say much more and share much more! But as I reflect further on my desire to include more examples and ideas in this book, it has occurred to me that I've given you more than enough information to start—and it is now your turn to go rushing out the door or into the kitchen or wherever and put to use one, if not several, of the many ideas and suggestions I've made in this book. And as is often the case, one discovery leads to another. Don't be surprised if, out of the many ideas I have shared with you, only a handful resonate with your own personal style and approach (for example, you will never shoot down from above simply because you have a fear of heights, or no matter how compelling the images might be, your own personal vision just cannot seem to embrace the extemely broad view of the very wide-angle lenses).

In addition, this isn't a race that you are entering, so *do* allow yourself to be distracted by *all* that's in front of you (and off to the sides and behind you), and make it a point to look at *all* of those distractions with a lens up to your eye whenever possible. Really knowing how your lenses "see" will become an integral part of your daily vision, not only saving time in deciding what lens to reach for but in forming an effective composition in your mind ahead of time. Seeing creatively is the reward of constant practice, and that practice relies on you always remembering to ask the question "What if . . . ?" relative to lens choice, point of view, direction of light, weather, and season—and always, at least in the beginning, with the camera and lens up to your eye, if only to confirm that the shot is compelling from where you are sitting or standing or kneeling or lying. You cannot train the eye to "see," at least initially, without placing a lens in front of it. So

at least in the beginning, spend an hour or two each week just looking through your lens and camera at various focal lengths, up or down, from side to side, and from various points of view. I've also attached a "Mental Checklist" for you (**opposite**) to serve as a reminder of what I call "The Essentials of Seeing."

The telltale signs of a learned vision are: When you sit down in a restaurant and instead of picking up the glass of sparkling water to quench your thirst, you are picking up the glass and "seeing" some incredible macro shots within the glass and you remark, "If only I had my macro lens." Or when, as you walk through Central Park in New York City, you get down low at the edge of the flower beds, and imagine a wonderful wide-angle shot with the flowers in the foreground as the distant trail meanders off in the background and you remark, "Oh, if I only had my wide-angle lens." And finally, when you "see" the many "landscapes" in

Keep in mind the following as you work:

1. Relative to depth of field, what kind of picture am I taking? Storytelling compositions require the use of apertures of f/16 or f/22. Singular-theme compositions require the use of apertures of f/4 or f/5.6. And when depth of field is not an issue, use apertures of f/8 and f/11.

2. Are there any motion-filled opportunities here? Is there a chance to use slow shutter speeds (1 second, 1/2 sec., 1/4 sec.) to imply the motion of the wind, waves or water, or to create motion effects when shooting most any colorful subject by zooming the lens during the exposure at these same slow shutter speeds? Or should I use fast shutter speeds (1/500 sec., 1/1000 sec.) to freeze the action of waves, jumps, leaps, runs, splashes, and so on?

3. Should I be using higher or lower ISOs for this shot?

4. What are the wide-angle lens possibilities? Is there any foreground subject matter to exaggerate? Are there any strong lines to create a "vanishing" perspective (for example, trees that I could lie down at the base of, a stair railing or escalator railing I could place the camera on)? Is today's weather an opportunity to emphasize the vastness of the sky in relation to the landscape below? Is this the time to call upon my fish-eye lens so that I can exaggerate the foreground perspective?

5. What are the telephoto lens possibilities? Is the subject before me best isolated with the narrower angle of view of my telephoto? Do I have a busy or colorful background that I can render as out-of-focus tones to emphasize the foreground or main subject? Is this the time or place to make the sun into a really big ball as it sets or rises?

6. Should I shoot from my eye level or knee level, or while laying down on my belly or back? Is there a nearby tree or some stairs that will give me some elevation so that I can shoot this scene from a high vantage point? Is there another picture within the picture I just composed? (Every composition offers up a macro opportunity at the least!)

7. Is this subject best shot now or later? Is it best photographed in frontlight, sidelight, or backlight? Have I arrived too early or too late? Should I use a reflector to add some fill light, or is this the time to call upon my flash? Does the sky overhead offer up a chance to shoot an expansive composition? Is this the kind of scene that can be shot in all four seasons?

8. Does it feel as if the landscape, cityscape, or seascape is missing something? Perhaps the scene before me is best used as part of a Photoshop composite.

* It will help your vision tremendously if you bring a healthy dose of curiosity with you. Become a child again!

that rusty wall under that steel bridge, it's fair to say your journey of unlimited potential has finally began.

I know, of course, that I'm not the only one who is truly enthusiastic about image-making. You are obviously enthusiastic, too. Otherwise, why would you have bought this book? So I will leave what happens next up to you, and as your vision begins to expand in areas that you thought were once unattainable, please share your enthusiasm with others, myself included. I am easily found on the Web, so drop me a line or feel free to share a story along with a photo. I can't promise I will always have time to reply, but trust me that I truly appreciate your taking the time to share your love of image-making with a like-minded shooter. And as I say at the close of all of my videos on YouTube, "Until next time, you keep shooting!"

INDEX